MAJOLICA

Mike Schneider

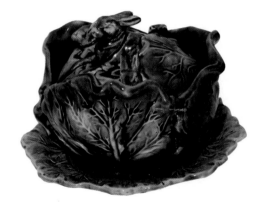

77 Lower Valley Road, Atglen, PA 19310

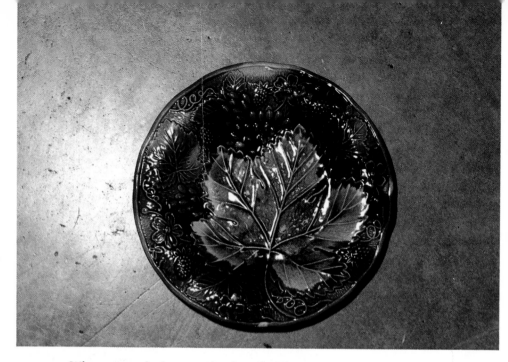

Whoever made them made a bunch. This 8-inch grapeleaf plate is seen more often at shows and shops, at least in the midwest, than any other majolica plate. This one is in especially nice condition. Unmarked. Estimated value: $55. Photo courtesy of Gloria Swingle.

Title page photo:
Covered bowl and underplate depicting rabbits in the cabbage. None of the pieces are marked, 5¾ x 7½ inches. Estimated value: $425. Richard Christen Collection.

Copyright © 1990 by Mike Schneider
Library of Congress Catalog Number: 89-64084

Printed in The United States of America
ISBN: 0-88740-769-2

We are interested in hearing from authors
with book ideas on related topics.

Published by Schiffer Publishing Ltd.
77 Lower Valley Road
Atglen, PA 19310
Please write for a free catalog.
This book may be purchased from the publisher.
Please include $2.95 postage.
Try your bookstore first.

Dedication

This book is dedicated to my wife, Cindy, who endured life as a writer's widow during the final weeks of its preparation.

Same plate as last picture but different colors. This one is rarer but not exceedingly so. No mark, of course, and 8 inches in diameter. Estimated value: $65. Photo courtesy of Betty Heath Antiques.

Acknowledgments

Several years ago an apparently inexperienced dealer at a local antique mall grossly underpriced the set of three wild rose on tree bark pitchers pictured below. I got to the mall about three minutes after the dealer had left, according to the clerk, found the bargain too tempting to resist and scarfed up my first three pieces of majolica. The purchase planted the seed for this book. To that anonymous dealer I'll be forever grateful.

Among the identified people who made special contributions, Richard Christen, who allowed me into his home to photograph his magnificent collection of majolica, stands at the top. Richard's collection is

This pattern featuring tree bark and wild roses is fairly common. It's also seen with a white background and with a blue background. Sizes left to right 5⅞, 9½ and 7 inches. No marks. Estimated values, l to r: $100, $190, $140.

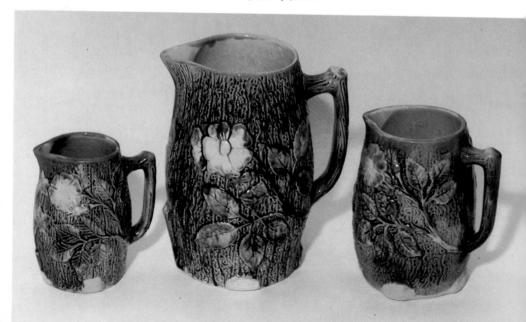

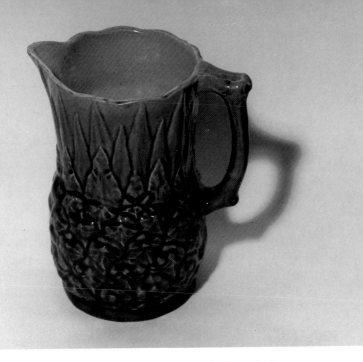

The pineapple is another common majolica motif. This pitcher is 6¼ inches, unmarked. Estimated value: $90. Photo courtesy of Country Heirs.

not as large as some others around the country, but it's of a quality that could easily form the nucleus of any museum collection and does form the nucleus of this book.

Right up there with Richard are Dorothy Coates and Judy Fedako, both of whom gave up their time to make this book better.

I'm also grateful to the many antique dealers, mall owners and show promoters who allowed me to take the photographs. In alphabetical order they are: Chuck Allen and Peggy Sause, Almond Tree Antique Center, Antiques of Chester, Twyla Barron, Rose Bessell, Jeanne Bostwick, Carter Boylan, Brothers Antique Mall, Country Heirs, Country Roads, Dover Antique Mall, East Oberlin Flea Market, Everett and Cynthia Eckstein, Sharon Fabbro, Judy Fitzpatrick, Donna Freter, Barbara Hall, Mary and Bill Hallier, Betty Heath, Rod Hollen, Dee Ann Hoopes, Jamie's Flea Market, Kerry and Kim Kirkpatrick, Jan Looney, Mansfield Antique Show & Flea Market, James McAdams, Fred McMorrow, Marge and Doug

Mulder, North Ridgeville Antique Mall, Northwoods Antiques, Julie Pavlison, Plymouth Antiques, Raggedy Antiques, Mary L. Rehker, Jim Reynolds, Dan Schneider, Shawville Station, Marcie Smith, Southern Lorain County Historical Society, Frank and Lillian Stigliano, Stockwell Promotions, Gloria Swingle, Jim Taylor, The Antiques Loft, Irv Tudor, Leam Williams, Rosemary Winterfield, and anyone else I might have inadvertently left out.

Last, but not least, my friends and neighbors at Herrick Memorial Library, Wellington, Ohio, cheerfully ferreted out research material from libraries around the state and across the country. They have my gratitude and good wishes.

Some pineapples are green on top, some are green on the bottom. This unmarked pitcher is 7 inches tall. Estimated value: $50; in better condition: $100. Photo courtesy of Jeanne Bostwick.

Preface

You're browsing at an antique show when suddenly a piece of pottery three rows over screams at you. You hurry through the crowd to view it closer and discover it's an object of contradictions.

It's graceful, awkward, elegant, crude, refined, vulgar, attractive, revolting, beautiful and repulsive. Above all it's colorful, vivid and shiny. You want to turn away but some mystical force keeps your eyes riveted.

The particular piece you're staring at is a pitcher. Its handle looks like a piece of a bent tree branch, the bark still attached. The cross sections of several other branches surround the bottom of the pitcher, as though it was sitting on them. A bird's nest with eggs in it, and a bird flying to it, decorates the side of

This pitcher stands 9½ inches and is an excellent example of the workmanship found on unmarked majolica. Estimated value: $350. Photo courtesy of Mary and Bill Hallier.

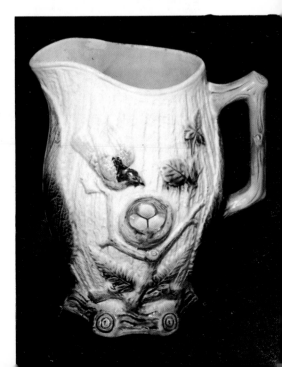

the pitcher. They are in relief. The eggs are robin egg blue but some of the brown paint of the nest has run on them making the eggs bi-colored. Some of the green paint from the leaves of the tree has also run, seeping into the scene's white background. The bird is a combination of colors, dark blue, light pink, yellow and white.

Slowly you begin to imagine a weird character who long ago painted the pitcher while dressed in a Hawaiian shirt, madras tie, paisley skirt, plaid polyester sport coat, and florescent jellies.

If you ever experience this sensation there's no need to call your analyst to tell him you're going crazy. The simple diagnosis is you've just discovered majolica, the soft-bodied, lead-glazed, high relief pottery of the Victorian era.

The weird character you imagined painting the piece was probably a normal teenage girl who worked sometime during the last third of the 19th Century. Instead of florescent jellies she probably wore black oxfords, a plain muslin dress instead of a paisley skirt.

Her employment was more than likely in Ohio, Pennsylvania, New York or Maryland. Indiana,

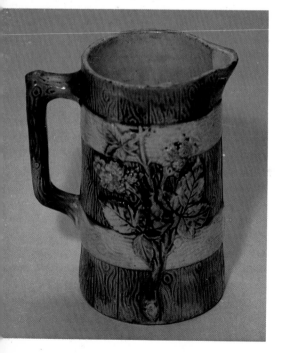

A fairly common variety of the popular flower and fence motif, this pitcher is 7¼ inches tall, and has no mark. Estimated value: $95. Photo courtesy of Fred McMorrow.

Connecticut, New Jersey and New Hampshire are also possibilities. Less probable but still possible are England, France, Italy, Austria, Germany, Spain, Portugal and Belgium.

She undoubtedly worked with a finely decorated identical piece sitting in front of her, the prototype having been finished by a master paintress or a master painter. Or perhaps the sample was several feet away, in front of another one of the many girls and women working at the same long table. Perhaps that's why the brush strokes weren't as accurately placed as they might have been—the piece she copied from was too far away to make out the detail. Maybe she needed glasses and couldn't afford them. Or maybe she was new, her skills not fully developed. Either way, it didn't make a lot of difference to the owner of the pottery. Majolica was popular. The piece would sell.

Odd color combinations? Many were purposely executed to comply with the gaudy tastes of the Victorians. Others, however, were accidental.

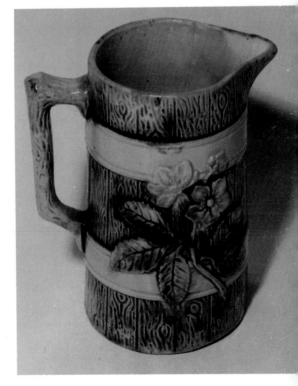

Here's a case where two pieces were apparently made from the same master mold with modifications added. The flowers of this example are different from the previous one, as are the bands. Check how the knots in the boards all appear in the same places. This pitcher, like the previous example, is 7¼ inches, also unmarked. Estimated value: $125. Photo courtesy of Judy Fedako.

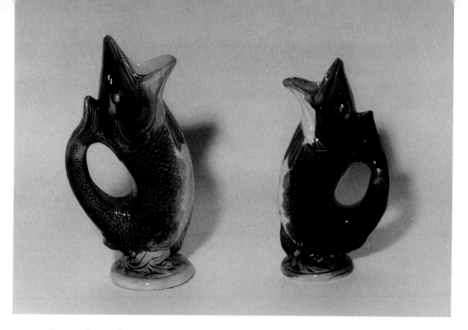

Figural pitchers are some of the most popular items with majolica collectors. Both of these fish pitchers are unmarked. The example on the left is 8 inches, the one on the right is 7 inches. Estimated values are $200 each. Richard Christen Collection.

This fish pitcher is rare because of its pewter lid. It's also quite large, 10¾ inches. The number "116" is impressed on the bottom. Estimated value: $325. Richard Christen Collection.

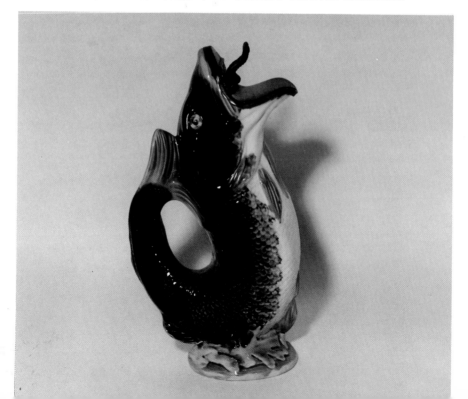

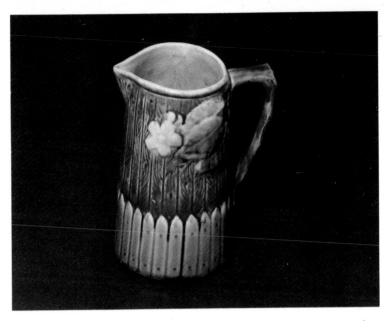

Yet a different version of a picket fence and flower design. This one is 6 inches tall and unmarked. Estimated value: $95. Photo courtesy of Antiques of Chester.

There's really no way of knowing how the pitcher came by its strange hues, but it's fun to speculate. They might have been the result of the dim factory lighting the girl had to work under, or of the even dimmer kerosene light she painted by after carrying additional work home with her at night. The yellow glow of kerosene tends to make one color look the same as another; she might have gotten them confused. Or maybe the factory had run out of the necessary colors and the boss told her to substitute as best she could. Majolica was too hot a product to set on a shelf while waiting for the paint department to deliver its goods. Finish it. Send it out to the waiting public.

The girl who painted the pitcher never heard of wage parity, the Equal Rights Amendment or Women's Liberation. Her lot in life was to work 12 hours a day for 25-cents while unskilled male laborers at the pottery received four times that much for the same 6 to 6 shift. Perhaps someday she would be lucky enough to marry one of those men. Together they

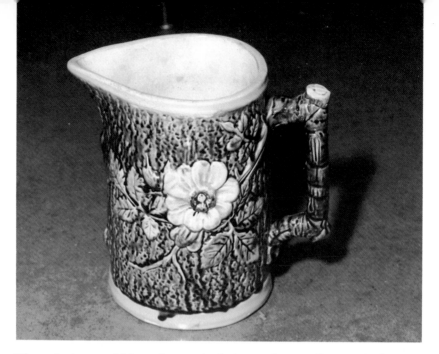

The painting could have been a little better but really isn't bad enough to hurt very much. Unmarked, 8¼ inches. Estimated value: $175; with slightly better painting: $225. Photo courtesy of Judy Fitzpatrick.

could bring in $7.50 per week, still have Sunday off to go to church, garden, can, wash clothes by hand and bake bread in a woodburning stove. But despite the hardships she faced, and the primitive conditions under which she worked, she splashed on paint with reckless abandon. She decorated vividly colored pieces of lead-glazed pottery, much of their charm lying in the boldness of their color schemes, and the wildness of their painting; whimsical designs from the mind of a teenager.

The weird but beautiful pieces the girl decorated during the late-1800s were gobbled up by anxious consumers nearly as soon as they had cooled in the kiln. Today they're gobbled up by an enthusiastic army of collectors and dealers nearly as soon as they're set out at antique shows.

If you're ever walking through an antique show and a piece of pottery screams at you, chances are pretty good it will be a piece of majolica. If you stop and listen to what it has to say, chances are even better you'll become friends for a lifetime.

Contents

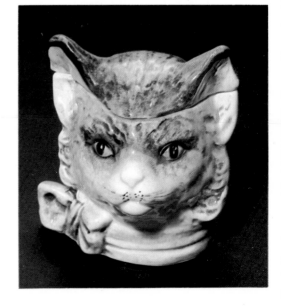

It seems the blue ribbon around this cat's neck would signify a boy but the figural humidor has a feminine look. The size is 4½" x 4". The piece is not marked. Estimated value: $215. Dorothy Coates Collection.

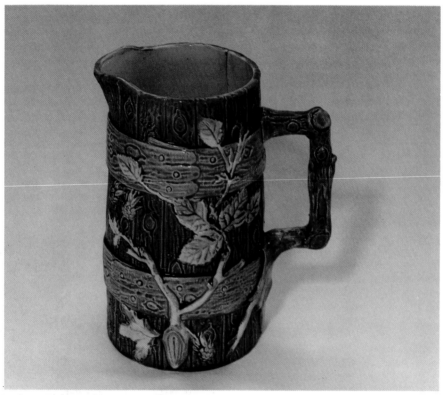

Another rather tall pitcher at 9¼ inches with a blackberry and wooden fence motif. Note the inside. No mark. Estimated value, as is: $85; without crack: $165. Photo courtesy of Fred McMorrow.

Chapter 1
Majolica
The Name

At London's Crystal Palace Exhibition in 1851, Herbert Minton, of Stoke-on-Trent, England, introduced a stunning new line of pottery he called "majolica." Of soft body, Minton's majolica was characterized by high-relief decorations that portrayed natural themes, bold, striking colors, and an extremely clear lead glaze.

The jury was so impressed it felt compelled to single out the strange but attractive new pottery in its report: "H. Minton & Co...stand foremost among the British exhibitors for the number, variety and beauty of their articles....The jury must specially mention...the garden-pots and vases modelled in imitation of the old Majolica ware, and not only remarkable for the success with which the effect of

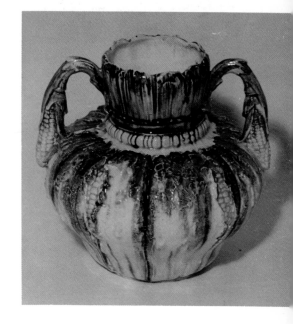

When you look closely you see that this is a corn vase. The size is 8 x 8½ inches. Impressed on the bottom is "REGIST/8020/1" on three lines. Estimated value: $250. Richard Christen Collection.

that ware it attained, but for novelty and beauty of design...."

While the new majolica captured the imagination of the Crystal Palace jury in 1851, over the next 50 years it captured the collective imagination of mid- and late-Victorians throughout the civilized world, especially in America.

Today's majolica collectors owe Minton, or more accurately Leon Arnoux the company's art director, a debt of gratitude for developing the lead-glazed pottery that spawned their hobby. At the same time more than a few of those collectors have cursed Minton for calling it majolica. Seldom do you find a more confusing name in the world of antiques.

Let's set the record straight.

Minton borrowed the name "majolica," from an opaque tin-glazed pottery Italy imported from Spain during the Renaissance. The tin-glazed ware was carried on ships from the western Mediterranean

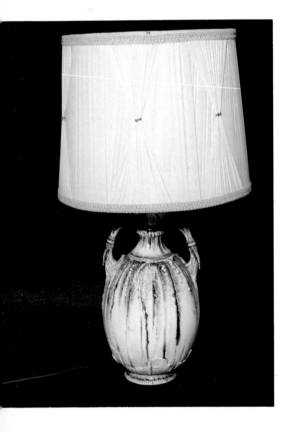

Sister of last picture that has been made into a lamp. Vase itself is 16¾ x 8¾ inches. Numerals "3009" and "73" impressed on two lines. Estimated value: $250. Richard Christen Collection.

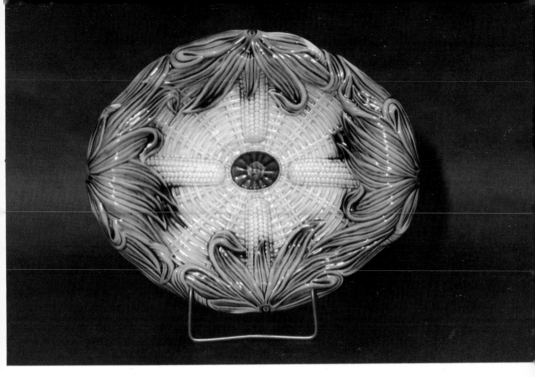

A nicely painted corn platter in mint condition. The small amount of green on the corn is due to the paint running during firing, a rather common problem. In this case it's not severe enough to affect value. Measurements are 13 x 11½ inches. Estimated value: $275. Richard Christen Collection.

island of Majorca, the Italian spelling of which was *Maiolica*. The importers tagged the pottery Maiolica, and the name stuck.

It wasn't long before Italian potters began turning out tin-glazed pottery of their own. From Italy it spread to France, Holland and England. The French called their tin-glazed pottery "faience," while the Dutch and English both named theirs Delftware, or Delft, after the city in Holland that became the center of its production in that country.

(While all these ripoffs probably irritated the Spanish potters, they didn't have a legitimate complaint. The Moors had brought the technique of making tin-glazed pottery to Spain with their invasions of the 8th Century. At the other end of the Mediterranean the Assyrians had the formula as early as 1100 B.C., and all of North Africa was making it long before Spain ever knew what it was.)

It was the French faience, specifically that of Bernard Palissy, that Minton sought to imitate and update. Palissy, who lived from around 1510 to 1590, changed the glaze from tin to lead, which in turn changed the pottery from opaque to clear. Also, like so much of the majolica collected today, Palissy relied on natural themes such as plants and animals, and developed the technique of applique, making his lead-glazed pottery motifs three dimensional.

At the time of the Crystal Palace Exhibition, Palissy pieces were in great demand in England and elsewhere, and were very expensive. Only the gentry could afford them. Forgeries abounded, but they were just as expensive since they were excellent in every detail (many are in museums today), and could be passed off as the real thing.

Then along came Herbert Minton and his lead-glazed pottery to solve the commoners' problem. He offered them a modified imitation of an unattainable antique at a very affordable price. For whatever reason he called his pottery "majolica," corrupting a romantic name long associated with the late middle ages. From that day forward the ceramic community, and later the antique community, has wrestled with Minton's misnomer.

While Minton might have erred by christening his lead-glazed pottery, "majolica," he certainly did no wrong. His introduction of the pottery in 1851 brought joy to folks during that era, and has resulted in a popular collecting hobby today. One stroll through an antique show to glimpse the delightful results of the lead-glazed pottery fad Minton started, will convince most people that the legacy of beauty he left behind far outweighs the resulting confusion over its name.

Small unmarked fern and leaf syrup, 4¼ inches. Estimated value: $190. Richard Christen Collection.

Chapter 2
Majolica
A Definition

It wasn't very long ago that collectors of majolica, and those who wrote about it, applied a very narrow definition as to what wares should be considered worthy of collection. The common criteria were when the piece was made, and to a lesser extent, its country of origin.

Leon Arnoux, a brilliant and innovative French potter, immigrated to England to become art director of Minton's in 1848. By 1850 he had perfected the technique to produce outstanding lead-glazed pottery. At the same time, on this side of the Atlantic, Edwin Bennett, a former British potter working in Baltimore, also discovered the process. Who was actually first is a matter of conjecture. But that year, 1850, has long been considered the beginning of the majolica era.

The end of the period has never been as well defined, different authorities and collectors favoring dates between 1890 and 1910, 1900 being the most common. By then the demand for majolica had definitely ebbed. Most American and British majolica potteries had either gone out of business, or turned their attention toward other types of ceramics.

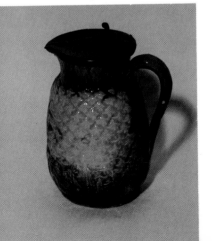

Wherever you find majolica you find pineapples. This unmarked piece is 6½ inches. Estimated value: $175. Richard Christen Collection.

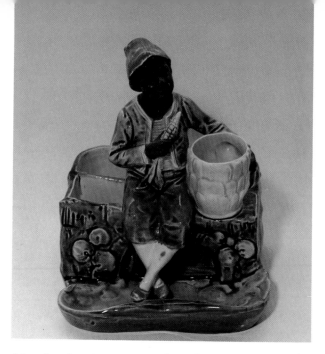

Everything for the cigarette smoker of a century ago. There is a compartment for cigarettes in the back. Matches go in the bucket, spent matches in the compartment on the left. On the right side is a striker that doesn't show in the picture. Size is 5½ x 7½ inches, with "7661" and "23" impressed on two lines. Estimated value: $350. Dorothy Coates Collection.

In Europe the craze died more slowly. During the early decades of the 20th Century potteries in France, Austria, Germany and Italy still produced lead-glazed pottery. Somewhat later Portugal and Poland began exporting it.

Most of the lead-glazed pottery that was made in Europe after 1900 is of a thinner body than the British and American wares turned out prior to 1900. On much of it the high-relief decorations are not nearly as prominent. In the past most collectors have shunned it. But setting strict limits on a collection of majolica causes problems.

For instance, Wedgwood didn't produce majolica and sell it as such until 1860. But set a Wedgwood lead-glazed pineapple teapot, made in 1762, beside a Wedgwood shell-and-seaweed "majolica" teapot made 100 years later, and only a museum curator or a Wedgwood scholar would realize the difference in age. For that matter, most of Josiah Wedgwood's ideas

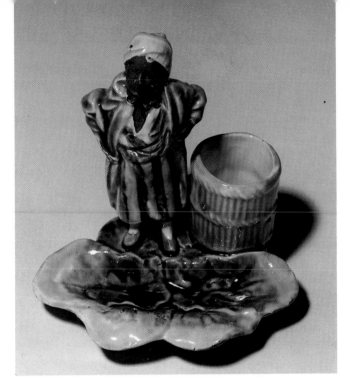

Match holder and ashtray. Size is 5 x 4½ x 4 inches. The piece is not marked. Estimated value $75, in better condition $200. Photo courtesy of Mary L. Rehker

about lead-glazed pottery evolved from his five-year partnership with Thomas Whieldon, which began in 1754. Whieldon's creations of the late 18th century are considered among the best in the field of lead-glazed pottery.

The same principle applies to pieces manufactured during the 20th Century. A wing-handled duck pitcher, clearly marked "Made in Austria" on the bottom, which signifies that it was produced no earlier than 1914, might have thinner walls than a figural pitcher made by Morley & Company in Wellsville, Ohio, during the early 1880s. But when they're sitting side-by-side in a china cabinet, both are equally beautiful.

If the thickness of the pottery alone determined whether a piece could be considered true "majolica," where would that leave the collector of Lettuce Leaf? This rare but lovely line of lead-glazed pottery, first produced by the New Milford Pottery Company of

New Milford, Connecticut, later continued by Charles Reynolds in Trenton, New Jersey, is thin enough to be called dainty, an adjective seldom used when describing American lead-glazed pottery. Yet even authorities who apply the strictest definition consider Lettuce Leaf true majolica.

Rather than using a calender or a globe to define majolica, it seems more appropriate to let the ware speak for itself. If a piece of pottery is soft-bodied, brightly colored, has high-relief decoration and a clear lead glaze, then that piece of pottery can, at least, fit well into a collection of majolica. If the high-relief decoration depicts a natural theme, so much the better.

Whether or not the collector calls it majolica is up to the individual. Since the word itself is a corruption of another word, and wasn't coined until 1850, it would seem inappropriate to apply it to a piece such as the 1762 Wedgwood pineapple teapot mentioned above. However, if collectors look upon their collections as lead-glazed pottery instead of majolica, they won't ever have to worry about tagging a piece with a name that doesn't apply, and will have no doubts as to what fits and what doesn't.

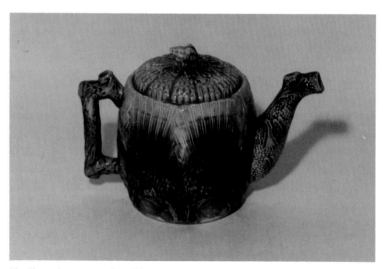

Shell and seaweed coffee pot, 5¾ inches. GSH monogram and "H16" impressed. Estimated value: $425. Richard Christen Collection.

Chapter 3
Marks
Their Importance

One of the most frustrating aspects of majolica, for novice and experienced collectors alike, is its general lack of marks. The beginner hesitates to buy an unmarked piece; the collector of many years experience finds mostly dead ends when trying to research his most prized examples. Appearing to have no regard for marks, a dealer will sometimes ask more for an unmarked piece of majolica than he will ask for a similar, marked piece sitting next to it. The situation is confusing. To the uninitiated, it's often exasperating.

To be sure, a lot of majolica is marked. The major British potteries marked most of their majolica from

Griffen, Smith & Company cauliflower teapot. Height 6 inches. GSH monogram. Estimated value: $190. Photo courtesy of Frank and Lillian Stigliano.

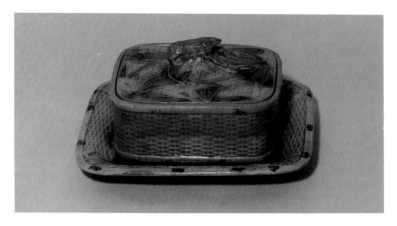

British sardine box with crayfish handle on lid. Some sardine boxes, like this one, were not attached to their underplates, while others were. Size of underplate is 4 x 8 inches. George Jones's monogram is on the bottoms of both the box and underplate. Estimated value: $650. Richard Christen Collection.

the very beginning. All goods imported to the United States, majolica included, had to be marked with at least the country of origin after March 1, 1891 in order to comply with the McKinley Tariff Act; some manufacturers added their names. And some of America's better majolica potteries—Chesapeake Pottery, Griffen, Smith & Company, etc.—also marked most of their output.

But by and large it was the American potters who were the main culprits in majolica's no-name game. If the American majolica that has survived is a realistic indicator, and there is no reason to think that it isn't, 90 percent of the lead-glazed pottery made in the United States was unmarked. Several factors contributed to this unfortunate situation.

Prior to 1876, most of the majolica manufactured in America was made with the express intent of imitating that which was being offered by the top British companies such as Minton's, W.T. Copeland & Sons, and George Jones. By producing somewhat reasonable facsimiles, American potters could under-sell their English competitors who were forced to add the high cost of trans-Atlantic shipping to their prices. At their enterprising best America's potters used imagination and creativity to devise similar but

Opposite of the previous picture, this box is attached to its underplate. Underplate is 3½ x 8 inches, British Registry mark. value: $600. Richard Christen Collection.

competing lines. At their enterprising worst they ripped off the British by purchasing finished pieces to use as mold cores.

After 1876 the large majority of American majolica potters were still imitators, but now they imitated not only English but also American wares. The Centennial Exposition at Philadelphia made the difference.

When the majolica of our most skilled potters such as James Carr, J.E. Jeffords, and Edwin Bennett was displayed there, it thrust the fanciful lead-glazed pottery into the American spotlight just as the Crystal Palace Exhibition had thrust it into the British spotlight 25 years earlier. Almost overnight majolica was in great demand.

Anxious to reap the financial rewards of the new fad, many journeymen potters struck out on their own, building small potteries wherever suitable clays and fuels could be found. At the same time, and for the same reason, a good number of already established potteries began manufacturing majolica either as a primary line or as a sideline.

A few of the new companies, among them the Chesapeake Pottery Company, Morley & Company, and Griffen, Smith & Company, made and sold majolica of a quality high enough to rival the finest imports. These companies held their heads high, marking most of their wares. Others didn't. Today we

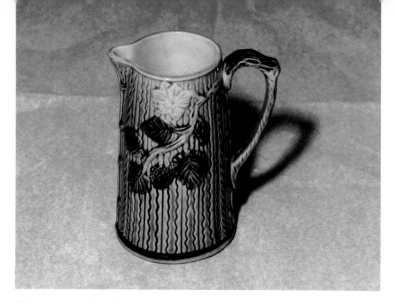

This is unmarked but attributed to George Morley since he made a lidded syrup of the same design. It is 6¼ inches tall. Estimated value: $95. Photo courtesy of Betty Heath Antiques.

can only speculate as to their reasons.

One possibility is that they had reputations to protect. For the most part American majolica was crude when compared to British majolica. Warped pieces slipped through inspection. Bisque wasn't always cleaned properly. Painting was done by unskilled workers at low wages, a fact often reflected in their work as colors overlapped, ran out of bounds, and ran together. An already established company enjoying a good reputation in other fields of ceramics, say yellow ware, hotel china or steamboat china, would naturally hesitate to lend its name to a less than top-of-the-line product.

Another possibility is that owners were afraid of lawsuits. Some of the pieces the American potters copied from both imports and domestic wares were carbon copies of the originals. Copyrights and patents weren't infringed upon—they were blatantly ignored. By not marking a facsimile piece the proprietor of a small factory could remain undetected when the rightful owner of the design tried to track him down.

Finally, some potteries were "contract" potteries. These establishments contracted with wholesale pottery distributors, retail stores and mail order

concerns to produce specified amounts of majolica per individual contract. The pieces were left unmarked, the purchaser later adding his own name to the wares, sometimes in the form of a paper label, more often by merely stating it in the advertising. The situation is similar to today's Sears Kenmore washing machine that's actually made by Whirlpool, or a J.C. Penney television that was made by RCA. There's also little doubt companies that marked their majolica took contracts, too, from time to time when the money was right. They would have been foolish not to.

What all this means to the majolica collector is that marks are much less important than design, quality, condition and rarity. If a piece is attractive, and the price is right, buy it whether it's marked or unmarked. Some unmarked pieces, many in fact, are of higher quality than a lot of those which are marked. A manufacturer's affinity for marks was no preventative for a grinder having a bad day at the wheel, or a paintress having a bad day with the brush.

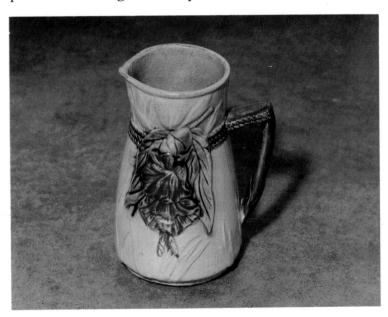

This pitcher was not painted completely (note the unfinished greenery around the top and bottom), a method often used to ensure a better looking product. The rope around the neck and on the handle is interesting. The piece is 6⅞ inches. It isn't marked. Estimated value: $85. Photo courtesy of Sharon Fabbro.

Chapter 4
Condition and Value

It doesn't take too many trips down the aisles of an antique show to discover that it's hard to find majolica in mint condition. Unlike expensive Haviland porcelain, or equally expensive R.S. Prussia, both of which were available at the same time as majolica, the original cost of majolica was generally much less, its low price relegating it to everyday use. Additionally, its vivid colors and overall cheeriness compared to the unexciting white ironstone, drab Rockingham and tired blue willow patterns popular for nightly meals during the last half of the 19th Century made

Here's the type of majolica to stay away from. This blackberry plate with a basketweave background is chipped, stained, worn, cracked and poorly painted. The plate shown is 8½ inches. It was also made in a 10½ inch size. White backgrounds are also known. Estimated value: not much. In good condition: $60; 10½ inch: $85.

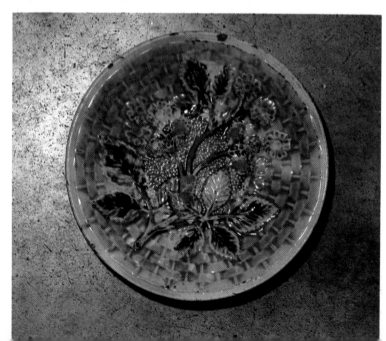

majolica a hit at the supper table. Seldom was it afforded a spot in the china cabinet. Couple hard use with its soft nature and it's easy to see why little has survived in tip-top condition.

While some types of damage knock down the price and the desirability of a piece of majolica, others don't.

Here's a rundown.

Pieces on which parts have obviously broken off—a cup with a missing handle or a figural ashtray with a missing head—are worth nothing. Don't buy them, they're junk.

Pieces missing detachable parts are usually worth something, but much, much less than if complete. An excellent example is the beautiful oriental teapot pictured below. The missing lid takes a full $100 off the estimated value.

Chips are common. A chip the size of a ball-point pen tip that would ruin a fine piece of Nippon porcelain or a Hummel figurine is generally considered much less significant on majolica, and doesn't detract much, if any, from its value. Somewhat larger chips on the bottom of a piece, or somewhere else where they don't show, are also little cause for concern.

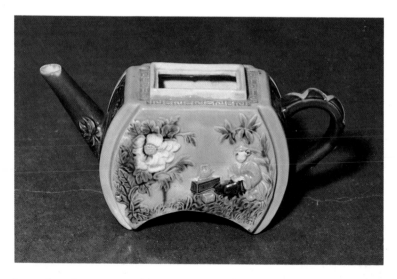

Just the thing to make a true majolica collector cry—a rare oriental motif teapot with its lid missing. Without the lid the unmarked piece is 5 x 9¾ inches. Estimated value: $95; with lid: $250. Photo courtesy of Donna Freter.

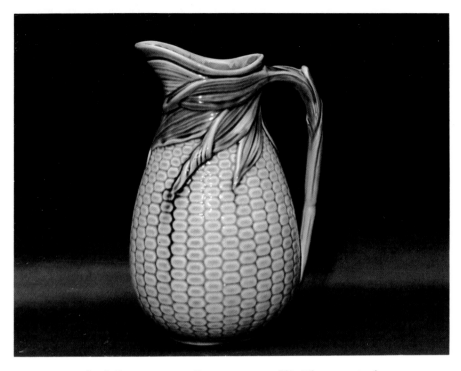

Unmarked Etruscan or Etruscan ripoff? This 10 inch corn pitcher is just like that made by Griffen, Smith & Company but is not marked. Whoever made it, it is beautiful. Estimated value: $350.

Once chips on common pieces get to one-half the diameter of a pencil eraser, it's time to start expecting a lower price. When they hit the size of jelly beans it's time to move on to the next table unless the piece is extremely rare.

Cracks are another form of damage often seen in majolica. Shy away from pieces with large open cracks and buy pieces with tight cracks only at a discount, only as shelf pieces, not as investments. Check for tight cracks on the insides of pieces as they have a way of camouflaging themselves in the relief of the decoration. Some writers suggest testing cracks for tightness by holding the piece to your ear and wiggling each side of the crack with your fingers. If the crack is tight you won't hear a grinding noise. Wiggle a loose crack too hard and you'll hear the dealer's teeth grinding when the piece breaks in your hands.

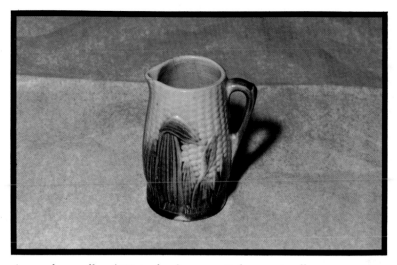

A much smaller (4½ inches) corn pitcher, actually a creamer. Unfortunately chipped and cracked. Estimated value: $35; better condition: $100. Photo courtesy of Betty Heath Antiques.

Crazing is present on most majolica. Soft-bodied ceramics aren't subjected to hot enough firings to sufficiently remove all moisture, and the bisque, before it is painted, is not dense enough to keep moisture in the atmosphere from creeping in. Over its life a piece of majolica continues to dry, which means it also continues to shrink. When that happens its vitreous glaze is subject to crazing; thousands of tiny cracks appear as the glass-like finish is stressed by shrinkage. Only visible up close, crazing is generally no cause for concern. However, after a piece has been used for years and years, crazing can allow foreign substances to slip in. Water, soap and food become a discoloring grout that fills the spaces between the tiny cracks. Sometimes the discoloring spreads under the glaze. Majolica on which the crazing has become a network of dark lines is best left with the dealer.

As far as sets that are missing pieces, the rules vary. An Etruscan shell and seaweed creamer will sell at half the price of a creamer and sugar set because the pattern is popular and many people collect it. A creamer from a more obscure pattern will usually sell for less than one-half of the price of the set because there isn't as much of a market for it. Cups and

saucers have individual values equal to the total of both. So do pitchers and mugs. So do syrups and underplates.

A lot of majolica has stilt marks, the result of setting on pointed nail-like holders during firing. These are integral to the manufacturing process and should not be considered damage.

Pieces that are out of round, pieces whose bottoms aren't flat, pieces with holes in the glaze and other imperfections that occurred at the factory should not be purchased unless discounted. The line, "That's O.K. because that's the way it was made," is as old as, "The check's in the mail." Don't fall for it.

In summing up condition and value, the key question to ask yourself before purchasing a less than perfect piece of majolica is, "Can I go elsewhere and get the same thing in better condition at the same price?" If the answer is, "Yes," politely thank the dealer and move on.

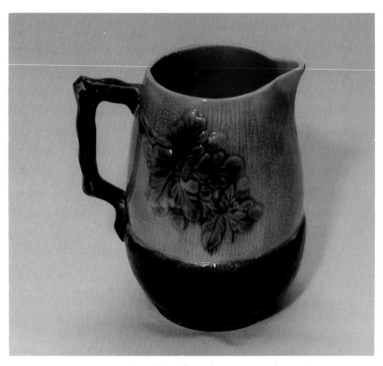

A very nice acorn and oak leaf pitcher in good condition except for some dark crazing. Unmarked, 7½ inches. Estimated value: $150. Photo courtesy of Fred McMorrow.

Chapter 5
Painting

Painting on majolica runs (no pun intended) from very sloppy to exceptionally neat. Part of the problem was unskilled and child labor, at least in America. The 1870 federal census showed 750,000 children between 10 and 15 years old gainfully employed. Over the next four decades, which encompass majolica's heyday, the number steadily increased. Since majolica was aimed at middle class families costs had to be kept down. One way to do this was to hire young girls to do the painting. Wages were as little as 25 cents per 12-hour day.

An excellent example of how a painter could ruin a piece by laying paint on too thickly. It subsequently ran when heated in the kiln. This 8 inch pitcher is unmarked. Estimated value: $65; with better painting: $175.

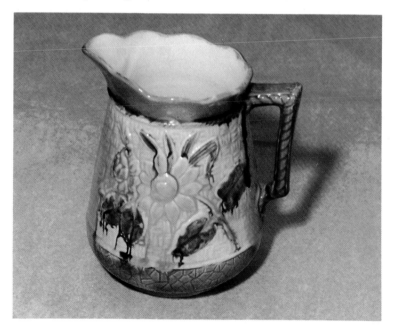

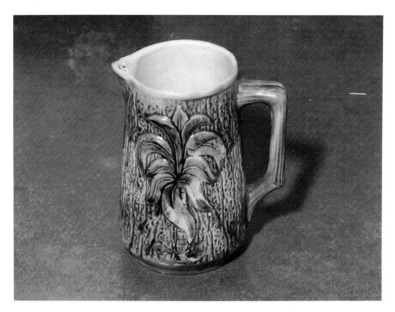

Here is another fairly poor job of decorating but this piece wasn't hurt as much by it as the preceding piece. The brown in the leaves is not as noticeable, and palms are rare on majolica. This pitcher is 6½ inches. It is not marked. Estimated value: $60; with better painting: $100. Photo courtesy of Irv Tudor.

A skilled worker, be it a master painter, master paintress or master decorator, painted an example of each different piece as a model from which others would work. The less skilled would then copy from the model as best they could. Some of their work reflects natural talent or long experience. Some of it looks like drunken daubings.

Also, the running of paint was inherent to majolica. Some potters turned this problem to their advantage by offering pieces with mottled designs, all of the colors running together to form interesting abstractions. Others sidestepped it by not painting as much detail in the raised motifs.

Overall the British did a much better job with the brush than the Americans. Austrian and French figural pieces were usually quite well done. Other European countries turned out generally acceptable painting with isolated exceptions.

Dealers who don't specialize in majolica tend to overlook the quality of the painting when setting

prices. They'll charge less than they should for a piece that's exquisitely painted, more than they should for a piece that's sloppily painted. Dealers who specialize tend to take painting into account.

The best advice is that if you're building a collection of majolica, or purchasing for investment, select only pieces that were painted by a talented hand. If you own some that weren't, attempt to trade up.

The casual majolica buyer, the person who is looking for a small pitcher to set on the shelf above the stove or a plate to fill a blank space in the rear of the china cabinet, could easily accept less than perfection, especially at the right price. The only problem is that majolica has a way of growing on you—today's casual buyer often evolves into tomorrow's ardent collector.

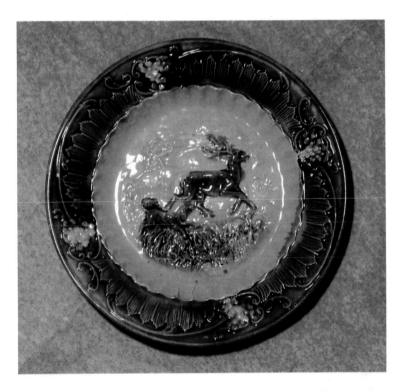

Reindeer and pickets. Crisp mold, some running of the paint but not bad. This plate is 9½ inches, unmarked and in nearly perfect condition. Estimated value: $90. Photo courtesy of Betty Heath Antiques.

Chapter 6
Care of Majolica

Caring for majolica is the simplest part of collecting it. Hand washing with soap and warm water will never hurt it. Avoid extremely hot water. When returning from shopping during the winter don't plunge your new acquisitions into warm water right after bringing them in from the cold; allow them to warm to room temperature first. Don't soak chipped or cracked pieces for extended periods as water can seep into the body of the ceramic. A discarded toothbrush is perfect for getting into all the pits and recesses of intricate patterns such as tree bark and basket weave. Allow majolica to air dry after cleaning, or dry it with a soft cloth or a paper towel.

Some collectors appreciate later European majolica, others don't. One nice thing, it generally sells for less than American and British majolica. This 7¾ inch Italian plate is very vivid and quite attractive. "Italy" impressed on back. Estimated value: $35. Photo courtesy of Irv Tudor.

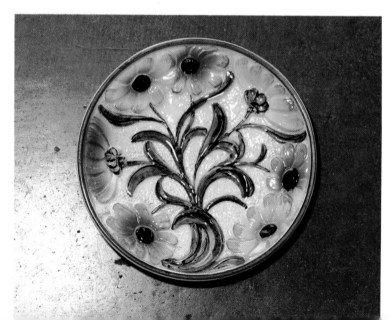

Avoid the urge to use bleach to clean dark cracks or dark crazing; it can cause the glaze to peel.

Repairs to valuable pieces are best left to professionals. Check with your local museum curator for a recommendation. You can bet the company he uses will be able to fix it so even the owner can't find where the damage was. If you happen to break a prized piece of majolica save all of the shards if you intend to have it repaired. Not only will the restorer be able to use them for the repair, he also will not have to guess at what the piece looked like before it was broken.

Chips on inexpensive pieces can often be camouflaged with a spot or two of paint, especially if the damage is not in a highlighted area of the design.

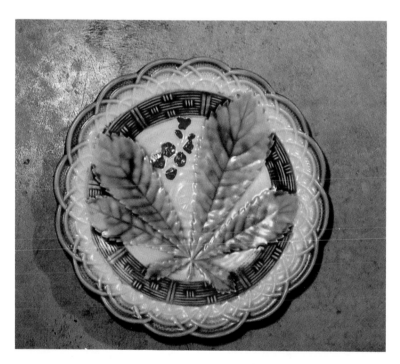

This plate, 8 inches in diameter, is marked only by an impressed 187 over an impressed 6. Note the crispness of the mold and neatness of the painting. Estimated value: $60. Photo courtesy of Cloud's Antique Mall, Castalia, Ohio.

Chapter 7
Pictures and Prices

Pictures

While some of the majolica pictured in this book is of high enough quality to be displayed in museums, none of the pictures were shot in museums. The pieces presented have been taken from two sources: private collections and dealers' stocks at antique shows and shops. They are the types of pieces to which everyone can have access, the types of pieces that can be touched, picked up and bought. Every piece in this book should be available to the collector who is willing to spend the time it takes to find it.

Prices

The estimated values accompanying the pictures are based on condition, workmanship, rarity, and desirability. One thing to remember is that buying

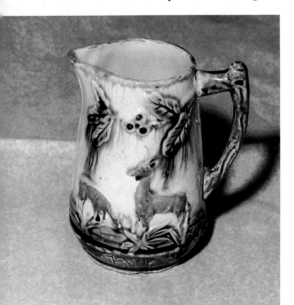

Many companies made pitchers depicting deer, generally on a white or cream color background. This one is 6¼ inches, and has a raised "B" on the bottom. Beck? Bevington?. Estimated value: $100. Photo courtesy of Betty Heath Antiques.

majolica is very much like buying a car—keep searching long enough and you'll probably find someone who will give you a better deal.

PITCHERS

Judging by their availability at antique shows, more majolica pitchers were potted than anything else including plates. Very few have survived in mint condition. Most will have chips or cracks, a problem not uncommon to previous generations of majolica collectors. Larry Freeman, writing in the July 1946 issue of *Hobbies*, said that collectors of that era were already beginning to accept majolica pitchers with minor damage. It's only with envy and a bit of sadness that today's collectors can look upon the prices Freeman quoted.

"All through the 1920s it was fairly easy to find such (majolica) pitchers in antique shops for as little as one dollar. In the 1930s perfect pitchers were becoming more and more difficult to find and the price had risen to around four dollars. Now that we are well into the 1940s we find the demand still keeps up as strong as ever, that prices are higher than ever...."

A nice example of a cane pitcher, another popular pattern. Unmarked, 5½ inches. Estimated value: $110. Photo courtesy of Mary and Bill Hallier.

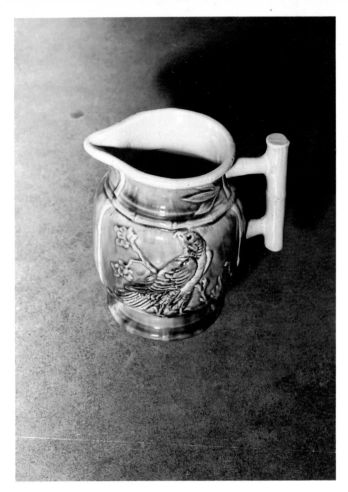

This bird pitcher with bamboo handle is not marked. It stands 6 inches high. Estimated value: $175. Private collection.

This pitcher is 5¾ inches. It has no mark. The painting is fairly nice. Estimated value: $75. Photo courtesy of Antiques of Chester.

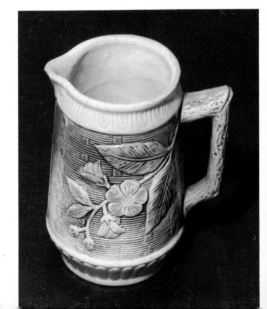

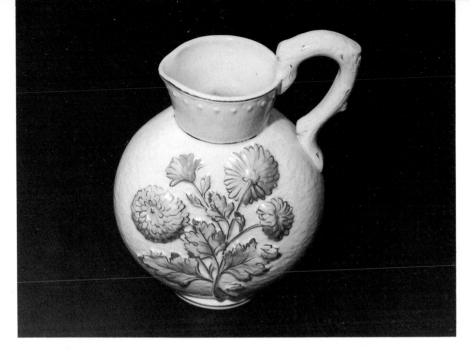

One look at this pitcher and it's easy to see why D.F. Haynes's Avalon Faience became so popular. It has fine styling—a stepping stone toward the simpler designs of art nouveau—and the painting is perfect. Marked on the bottom with Haynes's distinctive "Avalon / Faience / Balt" on the sides of a triangle. Estimated value: $110. Photo courtesy of Antiques of Chester.

Water lily is a common design on a lot of majolica, not just pitchers. This vase, which stands 6 1/2 inches tall, was made by Samuel Lear, of Hanley, England. Estimated value: $160. Photo courtesy of Jan Looney.

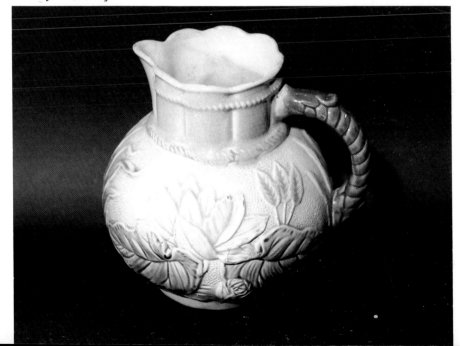

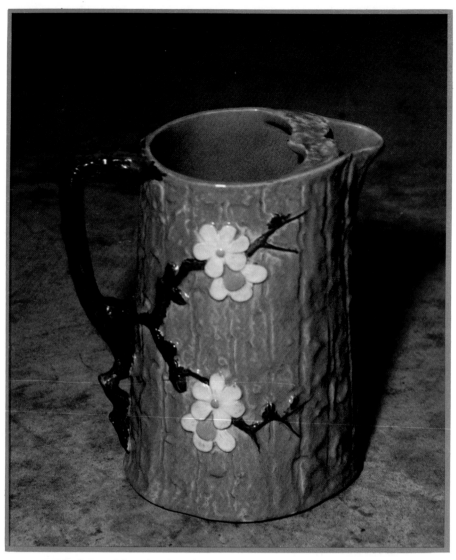

Made by Holdcroft, this dogwood pitcher is also found with a brown background, and with a white background. Impressed mark, "J. Holdcroft,", 9 inches tall. Estimated value: $175. Photo courtesy of Mary Lee.

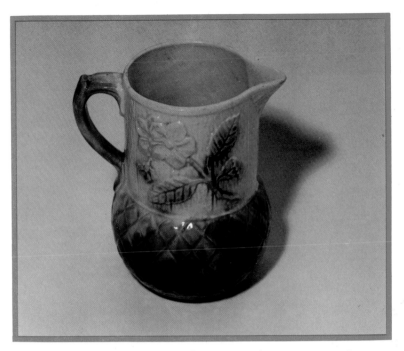

Straight sides above a bulbous bottom is a design commonly seen in majolica pitchers. This one is approximately 7 inches. No mark. Estimated value: $95. Photo courtesy of Twyla Barron.

Very similar in design to the previous example, yet very different. Note the anchor on the top band. No mark, 7½ inches. Estimated value: $100. Photo courtesy of Mary and Bill Hallier.

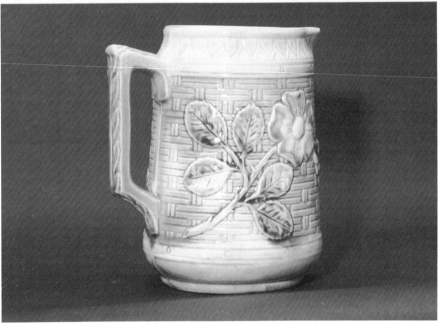

Quite often majolica pitchers and vases will have a front and a back; that is, one side will have much more detail. This 6½ inch unmarked basketweave pitcher is unusual in having different but just as intricate designs on both sides. Estimated value: $40; in better condition (note chipped spout): $135.

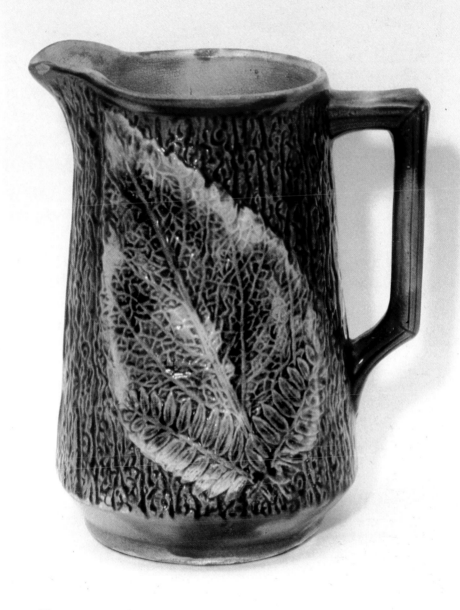

The more you look at majolica the more you see, such as the ferns at the base of the leaf. Unmarked, 8 inches. Estimated value: $120.

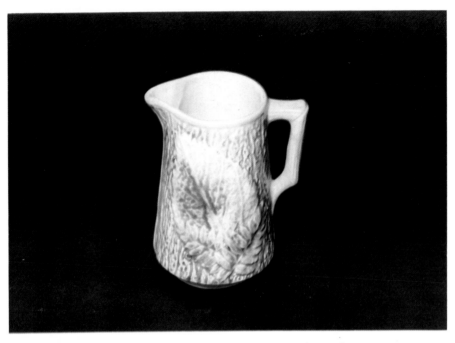

Similar but smaller and lighter in color than the previous example. Also unmarked, it's 5½ inches tall. Estimated value: $75. Photo courtesy of Everett and Cynthia Eckstein.

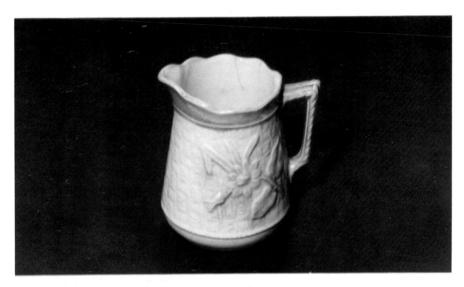

This is an example of one way potters avoided poor painting—they simply did less of it. The sparse application of pastel green on this 4½ inch creamer gives the piece a charm all its own. Unmarked. Estimated value: $55. Photo courtesy of Julie Pavlison.

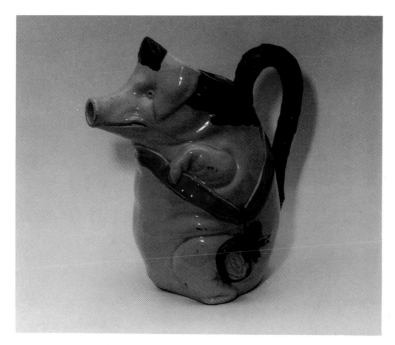

A pig carrying a ham; what could be more disgusting but lovable?
This 9⅜" figural is marked on the bottom with an impressed "C
2" between an "F B" or "B B." The figures are quite large.
Estimated value: $280.

A nice water lily motif, the piece is 7½ inches, and unmarked.
Estimated value: $90; in better condition: $185. Courtesy of
Frank and Lillian Stigliano.

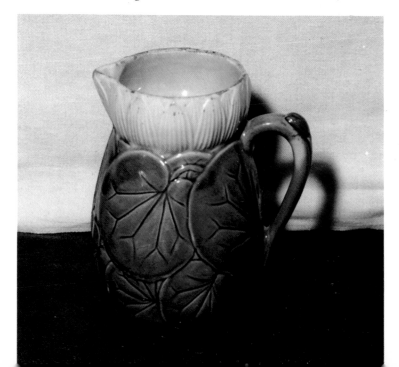

A 5½ inch Avalon Faience pitcher in excellent condition. Marked with Haynes' "Avalon / Faience / Balt" in triangle. Estimated value: $75. Photo courtesy of Betty Heath Antiques.

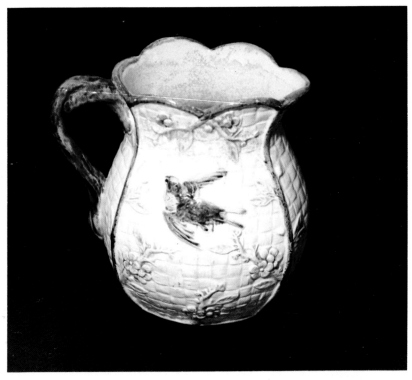

Birds were always popular motifs on majolica pitchers. This one is 7 inches tall, and unmarked. Estimated value: $150. Photo courtesy of Judy Fedako.

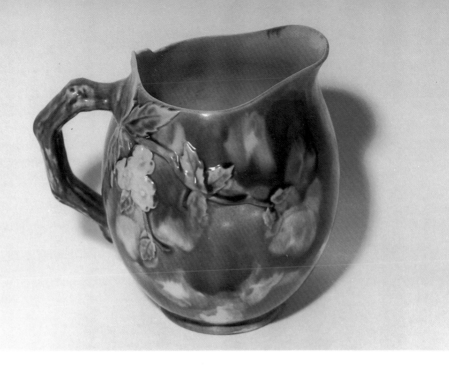

This Etruscan pitcher is 8 inches high, with a motif of flowers, leaves and spots. GSH monogram. Estimated value: $250. Photo courtesy of Judy Fedako.

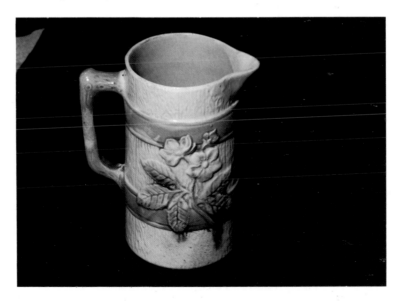

Banded fence and flowers with a white background. The light background on this otherwise common pitcher is somewhat rare. No mark, 7¼ inches. Estimated value: $95. Photo courtesy of DeeAnn Hoopes.

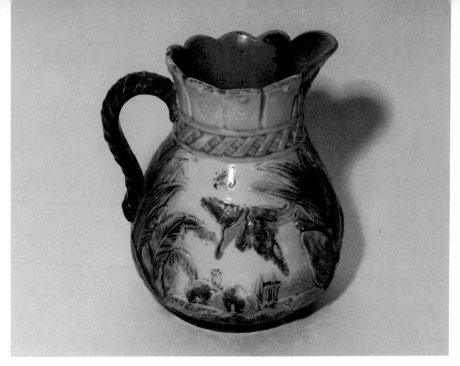

Shore birds, such as this heron, are often seen on majolica. Sometimes they are flying, other times they are standing. The unmarked pitcher is 8¾ inches. Estimated value: $110; in better condition: $250. Photo courtesy of Everett and Cynthia Eckstein.

Etruscan shell and seaweed. This pitcher is 5⅞ inches tall, carries the GSH monogram. Also made in sizes 6¾, 4¾, and 3½ inches. Estimated value: $300; 6¾: $375; 4¾: $225; 3½: $200. Photo courtesy of Judy Fedako.

This is a French pitcher, the mark saying, "E.G.," then a picture of a windmill followed by "ORCHIES / MADE IN / FRANCE," on three lines. Pitcher is 7¼ inches tall. Estimated value $100. Photo courtesy of Mary L. Rehker.

SYRUPS

Syrups are closely related to pitchers. They are smaller, of course, and always fitted with a lid, usually of pewter.

Flower syrup with pewter lid. This unmarked piece stands 5¾ inches tall. Estimated value: $250. Photo courtesy of Jim Taylor.

Stunning example of an Etruscan albino sunflower syrup. GSH monogram on both syrup and underplate, "H23" impressed in syrup. The piece is 8¾ inches tall. Estimated value: $650 as a set; syrup: $400; underplate: $250. Richard Christen Collection.

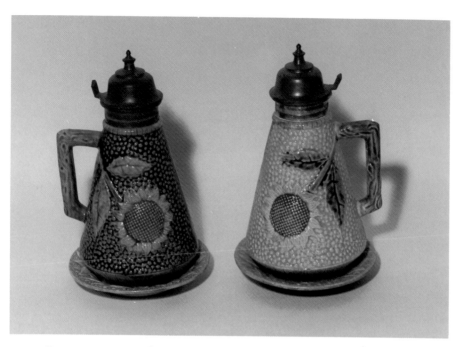

Same syrups as above but in different colors. The pink set is marked "ETRUSCAN" on both pieces. The blue set is marked with the GSH monogram on both pieces. Blue syrup has impressed "E23." Both syrups 8¾ inches tall. Estimated value of each set is $700; $450 for each syrup, $250 for each underplate. Richard Christen Collection.

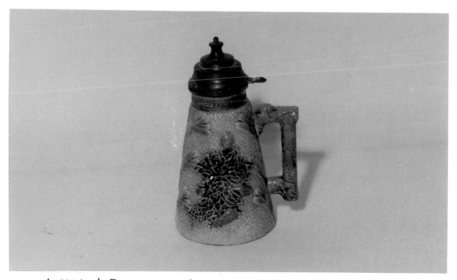

A 6½ inch Etruscan coral syrup marked with GSH monogram and impressed "E30." Estimated value: $350. Richard Christen Collection.

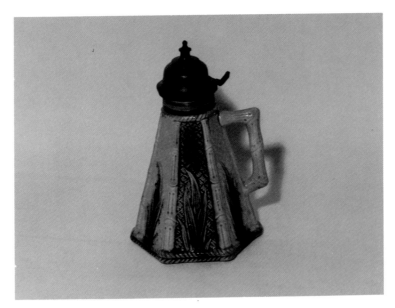

Etruscan hexagon bamboo pattern, 8 inches tall. Marked "ETRUSCAN" and "E-22." Estimated value: $450. Richard Christen Collection.

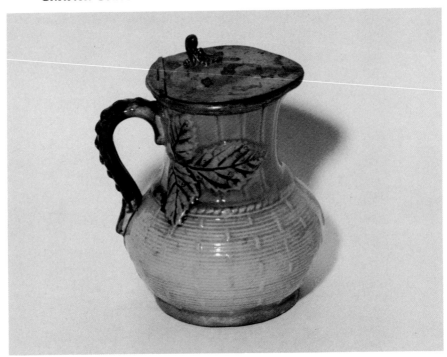

Basketweave and leaf syrup, 5½ inches. This unmarked piece shows excellent workmanship all the way around. Estimated value: $325. Richard Christen Collection.

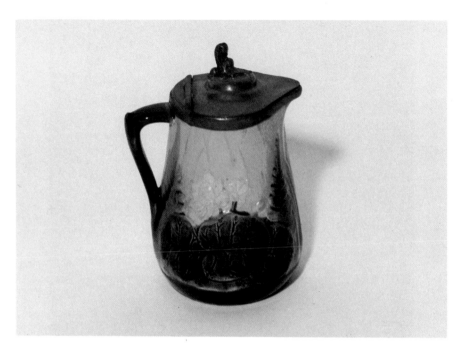

A 4¾ inch water lily syrup marked "HOLDCROFT," one of the better British majolica potteries. Estimated value: $210. Richard Christen Collection.

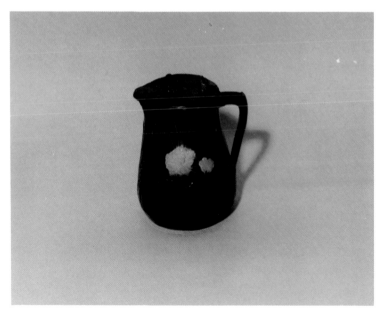

Like the previous example but in dark colors and slightly taller at 5¼ inches. This one is unmarked but obviously Holdcroft. Estimated value: $190. Richard Christen Collection.

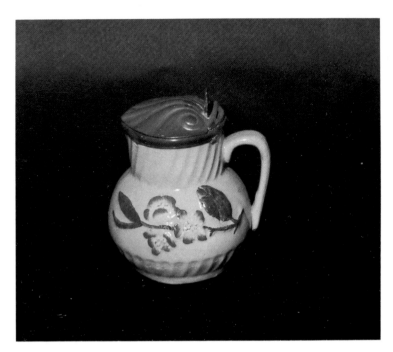

This small syrup (3¼ inches) is very much like something that might have been done by D.F. Haynes but is unmarked. Estimated value: $175. Richard Christen Collection.

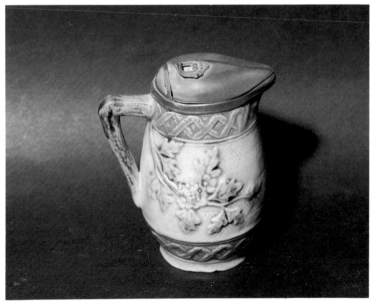

Majolica potters and consumers never got tired of flowers. Unmarked, 4¾ inches. Estimated value $160. Photo courtesy of Jan Looney.

Platters

While majolica platters are much harder to find than plates they're usually in better shape, having received less use. Most price guides undervalue platters.

This unmarked banana leaf platter was also made in a round shape. Size 13¾ x 9¾. Estimated value: $230.

Picket fence platter, 13½ x 10¾ inches. Here's a good case of the lack of a mark not reducing the value. This piece was perfectly executed, which is more than can be said for a lot of marked pieces. Estimated value: $300. Richard Christen Collection.

A lovely hanging platter to dress up the wall of any room. Impressed into the back of this 9 x 11¼ inch piece is either "9066" or "9906." Estimated value: $300. Richard Christen Collection.

An interesting aspect of collecting old ceramics, whether it's majolica or another type, is the difference in plants before hybridizing was developed. These strawberries are much different that what we buy at the store today. No mark, 9 x 12 inches. Estimated value: $140. Photo courtesy of Rose Bessell.

Painters of majolica were sometimes as creative with the backs of pieces as they were with the fronts. The "7" probably identifies the painter. Unmarked, 9 x 12 inches. Estimated value: $250. Photo courtesy of Everett and Cynthia Eckstein.

A large (9½ x 12 inches) and beautiful Estruscan oak leaf bread platter. Study the picture and remember it. The handle often gets broken off these pieces, and occasionally you'll find handle-less examples on which the painting has been touched up. They're still beautiful, but worth only a fraction of the full price. Estimated value: $140; without handle: $25. Photo courtesy of Rod Hollen.

An Etruscan geranium platter that's not often seen. This measures 10 x 12¼ inches, and carries the GSH monogram. Estimated value: $225. Photo courtesy of Mary and Bill Hallier.

PLATES

Plates are the backbone of many majolica collections. Not only are they easier to find than most other pieces, they are usually less expensive.

Flowers on a basketweave background. This 9¼ inch plate is unmarked. Estimated value: $85. Photo courtesy of James A. McAdams.

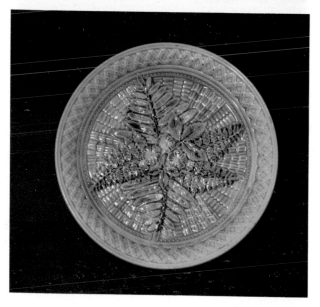

Similar colors to the last picture and possibly the same company. Also 9¼ inches, also unmarked. Estimated value: $85. Photo courtesy of James A. McAdams.

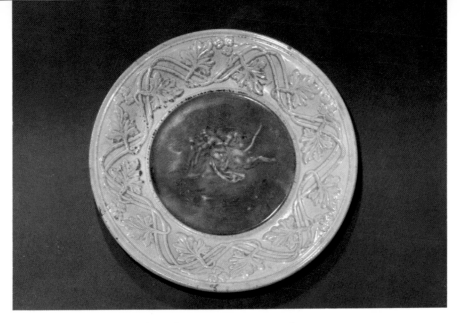

Here's a picture that shows no one, or rather no company, was infallible. On this Etruscan classical series plate the relief in the center can hardly be distinguished. It was probably made in an old mold. Size 9½ inches, GSH monogram. Estimated value: $15; on a better blank: $50.

Here's the reverse situation of the last picture. This 7¾" plate was made in a new mold as evidenced by the crisp detail. Nice painting, too. Unmarked. Estimated value $70. Photo courtesy of Jan Looney.

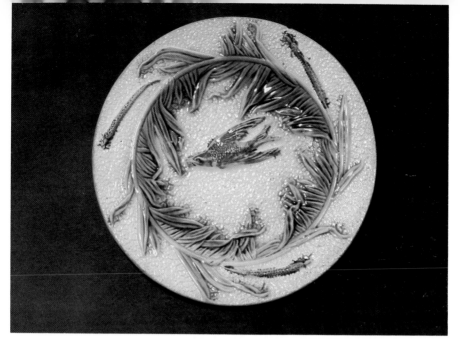

Here's a genuine piece of photogenic majolica—it looks much better in the book than in real life. Note the three insects crawling on the rim. No mark, 8½ inches. Estimated value: $60. Photo courtesy of Dan Schneider.

A 9¼ inch Etruscan apple and strawberry plate with a white background. Pink and blue backgrounds are also found. GSH monogram impressed. Estimated value: $125. Photo courtesy of Fred McMorrow.

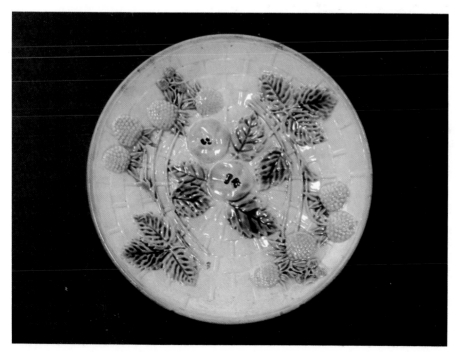

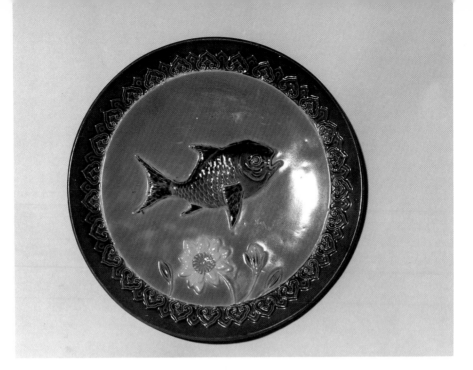

Another example of a plate painted in varying color schemes. Made by Holdcroft, it often pops up with the colors reversed— blue rim, brown background. With "J. Holdcroft," impressed on the bottom, the plate is 8½ inches in diameter. Estimated value: $120. Photo courtesy of Barbara Williams.

These two plates were photographed together as an example of how every piece of majolica is an individual. Once you start looking you find many subtle differences, for instance the two blue flowers on the left side of the piece. Marked with an impressed sunburst and an impressed "7." Each plate is 7⅝ inches. Estimated value: $50 each. Photo courtesy of Marcie Smith.

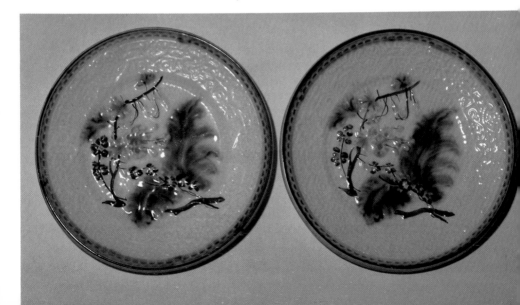

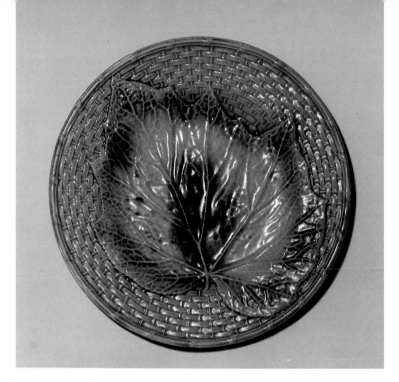

How about a leaf on a basketweave background? This unmarked plate is 7⅞" in diameter. The background pattern is exceptionally crisp. Estimated value: $60. Photo courtesy of Barbara Williams.

This 9 inch plate has "GVK" impressed on the back. Estimated value: $50. Photo courtesy of Jeanne Bostwick.

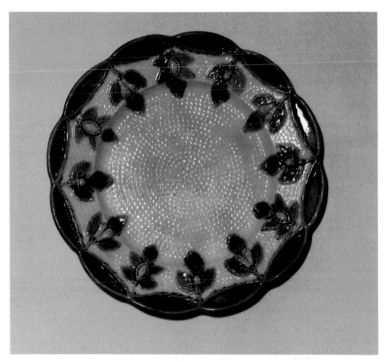

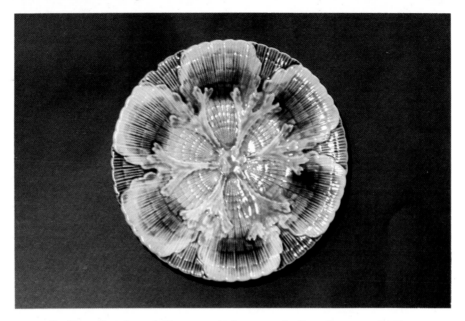

Griffen, Smith and Company's famous shell and seaweed. This particular plate is 7 inches. It also came in an 8 inch and a 9 inch size. GSH monogram impressed. Estimated value: $180; 8 inch: $250; 9 inch: $300. Photo courtesy of Dan Schneic

Parrots, love birds, finches or whatever you want to call them, the same plate comes with the colors reversed, white rim and blue background. No mark, 8½ inches. Estimated value: $100. Photo courtesy of Fred McMorrow.

This 8 inch plate was made by Utzschneider & Company. Mark is "SARREGUEMINES / MAJOLICA / 3," impressed on three lines. Estimated value: $65. Photo courtesy of Mary L. Rehker.

Also Utzschneider & Company, 8¼ inches. Impressed "SARREGUEMINES / 3 / 215," on three lines. Estimated value: $50.

This plate marked "Zell Baden / Germany / Handpainted" is as pretty as many American and British plates. Size 10¼ inches. Estimated value: $80. Photo compliments of Irv Tudor.

This 8 inch grape plate is also a later German product. The mark is "Black Forest/Art Pottery" on two lines enclosed in a box. Below the box is "Erphila Germany." The numerals 2114 are impressed on one line. Estimated value: $55. Photo courtesy of Judy Fedako.

Etruscan leaf plate, 8¾ inches. This was also made in a 7¾ inch size. GSH monogram impressed. Estimated value: $80; 7¾ inches: $70.

LEAF PLATES

A special type of plate common to majolica is the leaf plate or leaf dish, which was molded in the form of an actual leaf. Etruscan begonia leaf plates were the most popular. The endless variety of colors makes completion of a collection impossible. Leaf plates range in size from tiny butter pats to large platters. Quite often those seen at antique shows are in poor condition.

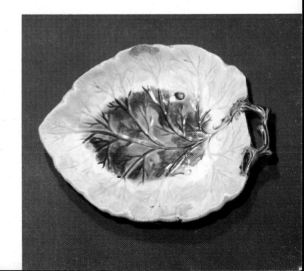

Unmarked leaf plate with twig handle. This one is 5½ x 7¼ inches. Estimated value: $25; without chip: $65. Photo courtesy of Everett and Cynthia Eckstein.

Etruscan begonia leaf, 7 x 9 inches. GSH monogram. Estimated value: $85. Richard Christen Collection.

An Etruscan begonia leaf in the rare green and white combination. GSH monogram impressed, 7 x 9¼ inches. Estimated value: $110. Richard Christen Collection.

Etruscan begonia leaf, 7" x 9". GSH monogram impressed. Estimated value: $85. Richard Christen Collection.

Etruscan, 6¾ x 9 inches. GSH monogram impressed. Estimated value: $85. Richard Christen Collection.

Unmarked, 5¼ x 7½ inches. These last two photos, when compared to the previous four, clearly point out the cut-above quality of Etruscan majolica. Estimated value: $50. Photo courtesy of Everett and Cynthia Eckstein.

Obviously this is made by the same company as last picture but certainly from a different mold. Note the serrated edge on this leaf dish that's missing from the other one. The size is a little different, too, 5⅝ x 7¾ inches. Also unmarked. Estimated value: $50. Photo courtesy of Marge and Doug Mulder.

The color combinations in begonia leaf are truly endless. This is 5¾ x 7⅞ inches, unmarked. Estimated value: $50. Photo courtesy of Judy Fedako.

There is no company mark on these 6½ x 5¾ inch leaf plates, the number 223 is imprinted on the bottom of each. Estimated value: $40 each. Photo courtesy of Antiques of Chester.

This picture and the one that follows show how the standard could vary within the same company. The painting is rather sloppy here. Dish is 6 x 6⅞ inches, unmarked. Estimated value: $40. Photo courtesy of Judy Fedako.

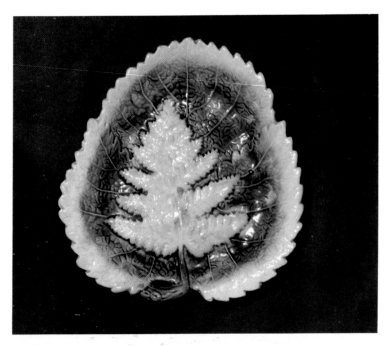

A little differently proportioned, 6⅞ x 6 inches, this is basically the same dish as the previous one, but look at how much neater the painting is. Also unmarked. Estimated value: $65. Photo courtesy of Mary and Bill Hallier.

A 6¾" x 6¾" leaf plate in solid green, surprisingly bearing a GSH monogram. Estimated value is $65. Photo courtesy of Mary and Bill Hallier.

An 8¼ inch Etruscan leaf plate. Note how the crazing adds to the beauty, as though the lines are veins in the leaf. GSH mark imprinted on bottom. Estimated value: $100. Photo courtesy of Judy Fedako.

SARDINE BOXES AND OTHER COVERED PIECES

Sardine boxes have really shot up in value over the last few years. What you could buy for $100 early in the 1980s will now cost $300 or $400.

Sardine boxes with legs or feet weren't made to set on underplates. In other words, no part of this box is missing. The lid is 4½ x 6 inches. British Registry mark impressed. Box is attributed to George Jones. Estimated value: $750. Richard Christen Collection.

This sardine box was also made to stand alone. Note the fish on the corners for feet. Top is 5¾" x 6½". No mark. Estimated value: $575. Richard Christen Collection.

A nest of hatching quail atop a covered bowl. This piece is 6½ x 7½ inches, "WFTS" / "20" is impressed on two lines. Estimated value: $550. Richard Christen Collection.

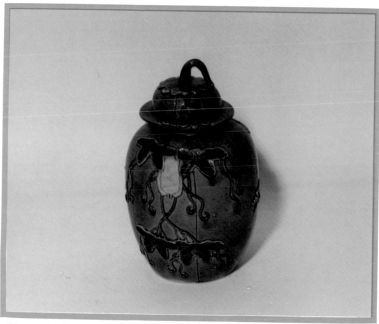

Unmarked ginger jar, 7¾ inches. Estimated value $175. Richard Christen Collection.

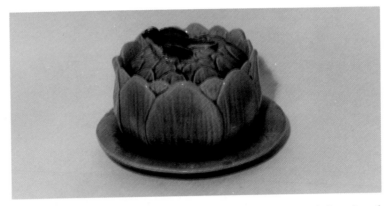

Covered bowl depicting a bird on an artichoke. Both bowl and underplate are unmarked, the bowl is 5½ x 7½ inches. Estimated value: $350. Richard Christen Collection.

CIGARETTE HOLDERS, ASHTRAYS, AND HUMIDORS

At one time many majolica collectors passed on these fanciful tobacco accessories, apparently because they are thinner-walled and lighter in weight than most other lead-glazed pottery. The insides and bottoms are usually white, and most of the bottoms will have a series or two of numbers impressed in them. Many of these depict black people; the renewal of interest in black collectibles during the 1980s has driven the prices quite high.

This is an ashtray, nothing else. Size is 4½" x 3½" x 4", and "0827" and "91" are impressed on two lines. Estimated value: $40; without chips: $135. Dorothy Coates Collection.

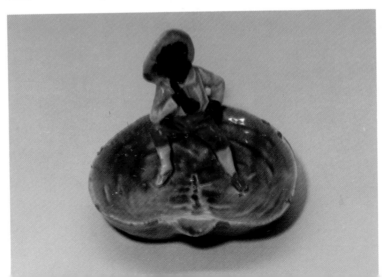

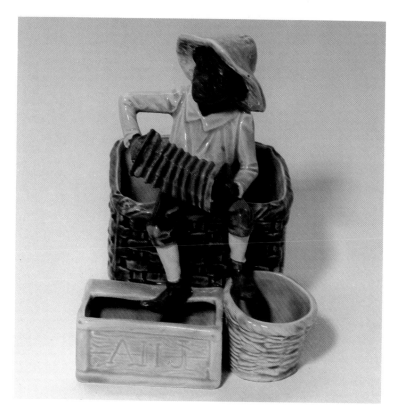

Smoking center. Cigarettes in back, matches on right, spent matches on left. Size is 7" x 4½" x 5", "6592" and "7" impressed on two lines. Estimated value: $325. Dorothy Coates Collection.

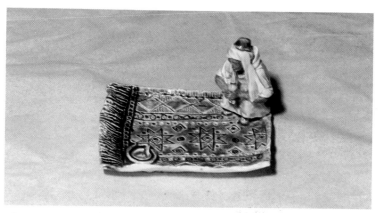

This snake charmer and cobra on Oriental rug is 3 x 3½ x 5 inches. Not known if marked. Estimated value: $100. Richard Christen Collection.

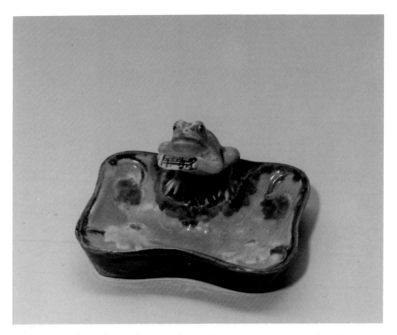

A frog at the edge of a pond croaking out tunes. The frog is 3 inches high, the other dimensions are 4½" x 3½". Impressed numbers are "6920" and "90" on two lines. Estimated value: $70. Dorothy Coates Collection.

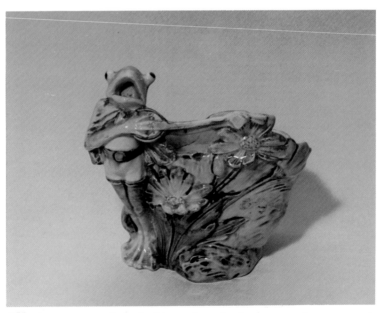

This frog is a cigarette holder only, which is somewhat unusual. The piece is 5½" x 5" x 3", with "F348" impressed on bottom. Estimated value: $110. Dorothy Coates Collection.

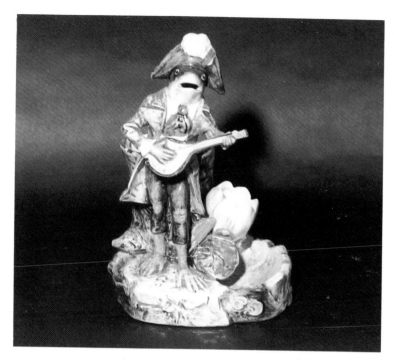

Why quit when we're on a roll. This music making frog stands 9 inches. Cigarette holder behind it isn't visible in picture. "4020" and "57" impressed on two lines. Estimated value: $250. Richard Christen Collection.

A mate to previous piece that has been made into a lamp with no damage done. The washboard-looking area on right is the match striker not visible in most of the pictures. Height 9 inches, marks not known. Estimated value: $275. Richard Christen Collection.

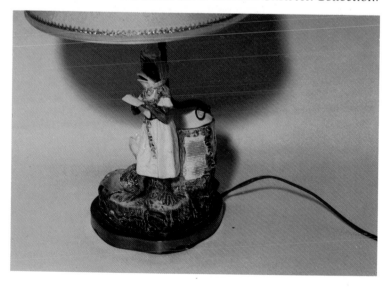

On this one cigarettes go in the dog's back, the rim of the hole
barely visible on the right. Unmarked and 7 x 5½ x 4 inches.
Estimated value: $190. Dorothy Coates Collection.

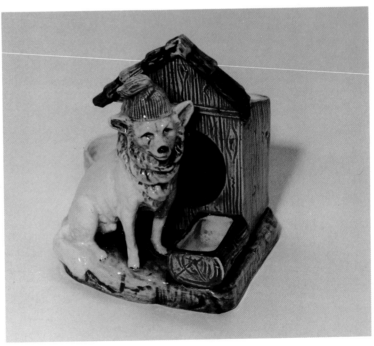

The overall dimensions of the piece are the same as the last but
the dog is much less foreboding. No mark. Estimated value:
$185. Dorothy Coates Collection.

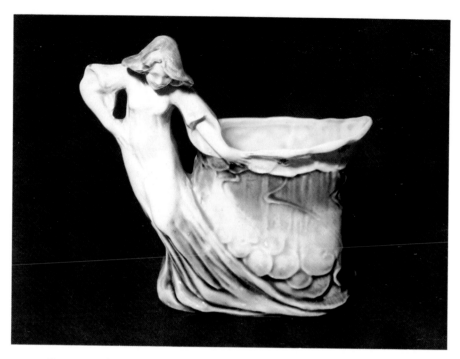

Cigarette holder, 5½ x 3¾ x 2½ inches. Unmarked. Estimated value: $125. Photo courtesy of Mary L. Rehker

Monkey matchholder, 5½ inches. Impressed on bottom is "520" plus a heart with an arrow in it, a circle around both. Estimated value: $160. Richard Christen Collection.

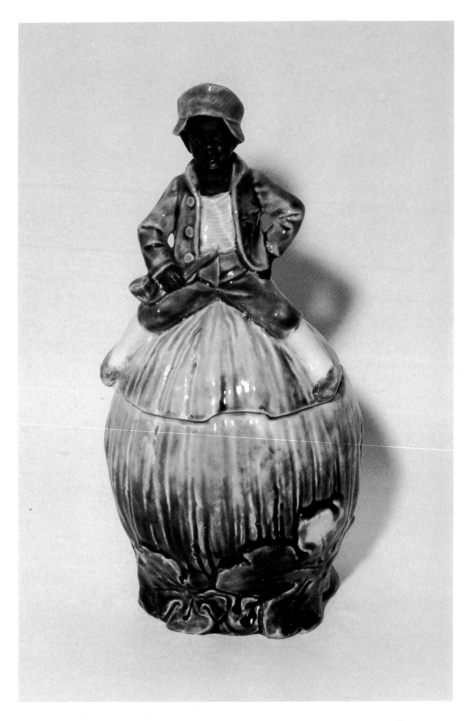

This magnificent humidor stands 11 inches tall. Impressed on bottom is "9907" and "46" on two lines. Estimated value: $675. Richard Christen Collection.

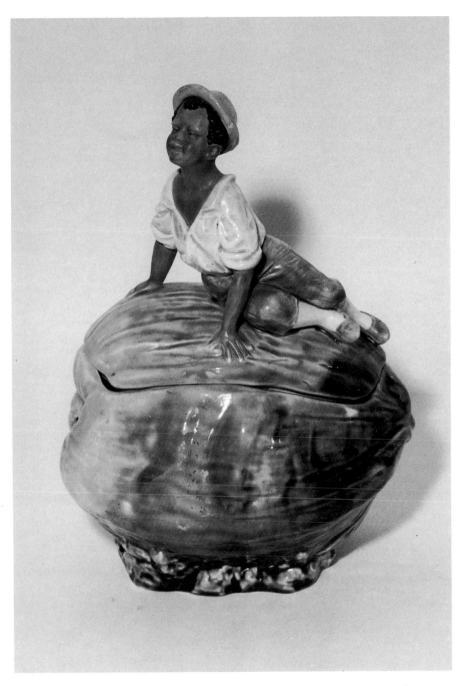

Obviously made by the same company as the previous example, these two renditions are the only ones known. Perhaps there were more. The impressed number in the bottom is either "66" or "99." The height is 9¾ inches. Estimated value: $675. Richard Christen Collection.

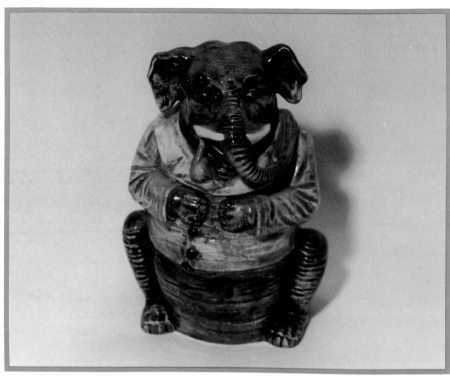

Nothing like a pipe-smoking elephant in which to store tobacco. No mark, 8½ inches. Estimated value: $300. Dorothy Coates Collection.

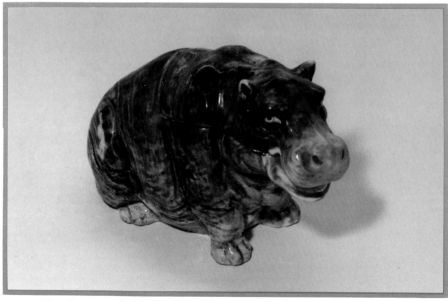

This hippo is 5 x 7 x 4 inches, and has "029" and "0" impressed on bottom. Estimated value: $285. Dorothy Coates Collection.

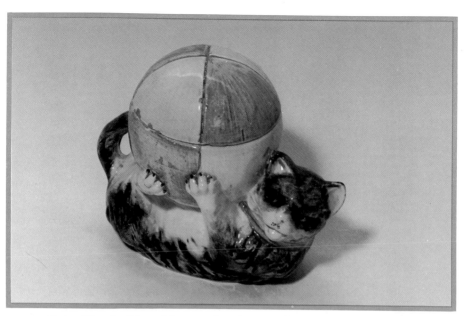

Cat with a ball humidor, 5½" x 6" x 3". The numerals "711" are impressed above a "1." Estimated value $100, in better condition $300. Dorothy Coates Collection.

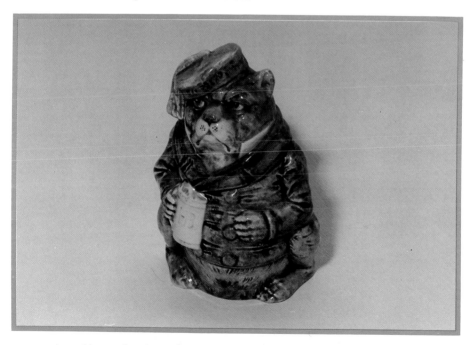

A real beer-drinking dog, it almost seems as though he's looking with disgust at the playful cat in the previous example. Height is 7 inches, "19" and "4869" impressed on two lines. Estimated value: $275. Dorothy Coates Collection.

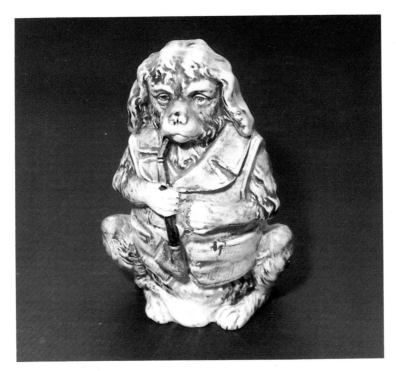

Obviously this is a much more sophisticated canine. Height is 7 inches, "6671" and "72" impressed on two lines. Estimated value: $300. Dorothy Coates Collection.

This poor fellow looks a bit sad, perhaps because of the lock. What the lock's significance is has not been determined. Standing 5¾ inches tall, the number "63" is impressed on the bottom. Estimated value: $175. Dorothy Coates Collection.

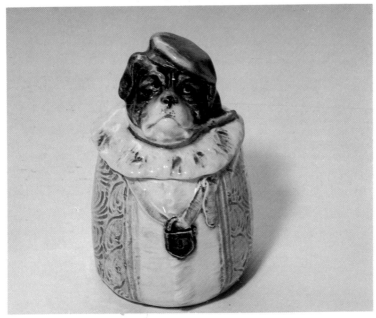

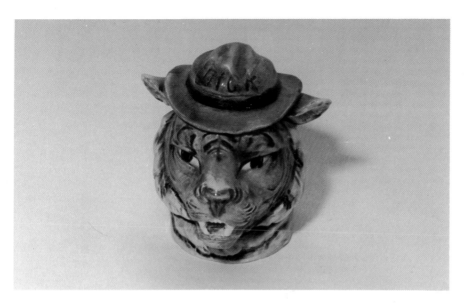

Dick the tiger, a 5½ inch humidor. Impressed numbers are "6037" and "53" on two lines. Estimated value: $200. Dorothy Coates Collection.

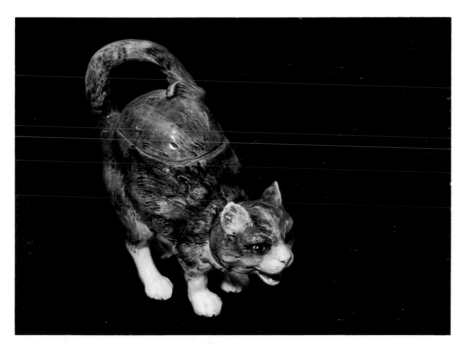

There's no shortage majolica cat humidors. This is the only known animal humidor that actually stands on its own feet. The four-footed cat is 8½" x 10" x 3½". No mark. Estimated value: $400. Dorothy Coates Collection.

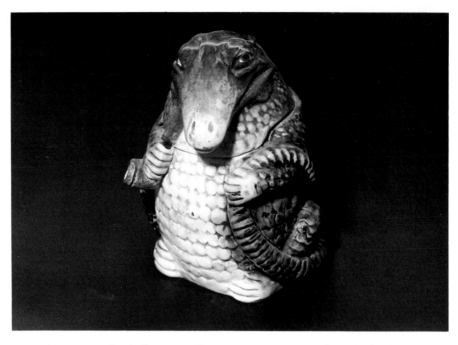

A pipe-smokin' alligator, 7" x 4½" x 4". Impressed on the bottom is "4271." Estimated value: **$325.** Dorothy Coates Collection.

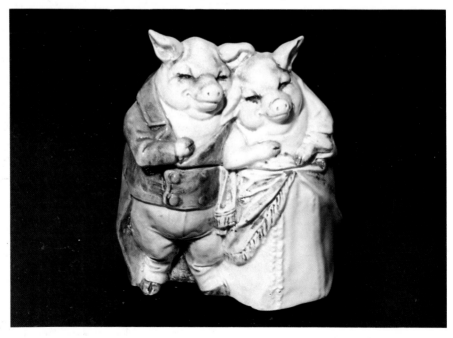

Not very many animal humidors are composed of two figures. The pigs are 7¼" x 6" x 4". There is no mark. Estimated value: **$400.** Dorothy Coates Collection.

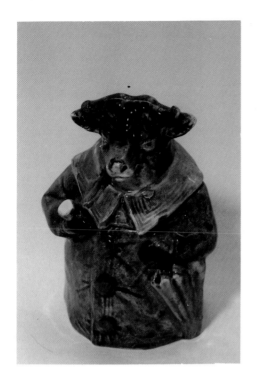

Bull (assumed) with a pipe and umbrella. The height is 6 inches, with "4870" impressed above "77". Estimated value: $300. Dorothy Coates Collection.

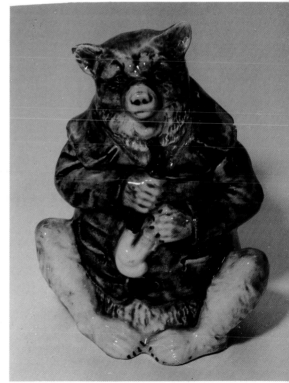

Wouldn't Smokey be ashamed! This bear is 7¼" x 5" x 3". Marked with "0676" and "9" impressed on two lines. Estimated value: $300. Dorothy Coates Collection.

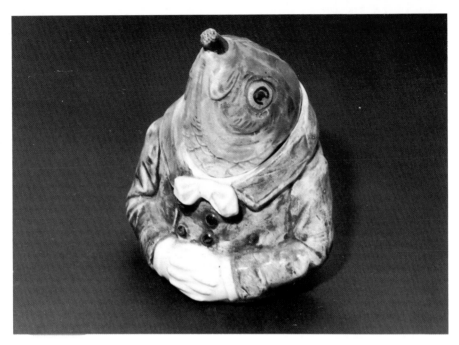

Cigar smoking fish is 7" x 6" x 4". Marked with an impressed "52" above four unreadable numbers. Estimated value: $350. Dorothy Coates Collection.

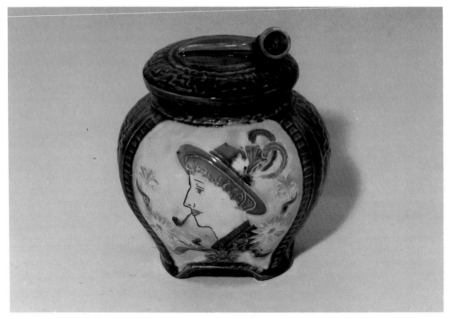

At 7½ inches, this humidor is tall for its shape and holds a lot of tobacco. "6617" and "97" are impressed on two lines. Estimated value: $145. Photo courtesy of Rod Hollen.

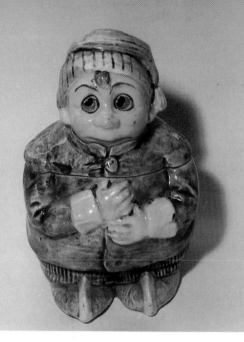

All figural humidors weren't animals. The mystery about this boy is whether it's a married piece, or was painted with different batches of paint. Size is 6½ inches, no mark. Estimated value: $180. Dorothy Coates Collection.

The brim of the hat is attached to the base. This humidor is rather tall at 9½ inches. Some say it's based on a charicature of Theodore Roosevelt. Impressed on the bottom is "572" and "3" on two lines. Also present is the painted numeral "59." Estimated value: $240. Photo courtesy of Rod Hollen.

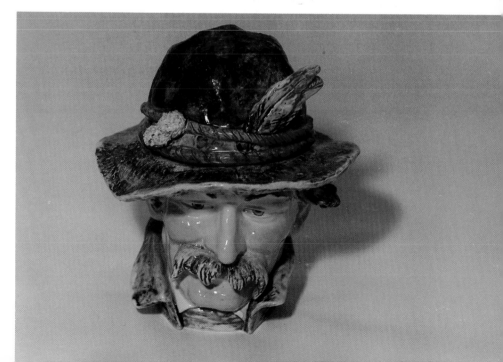

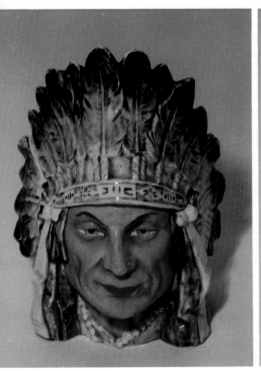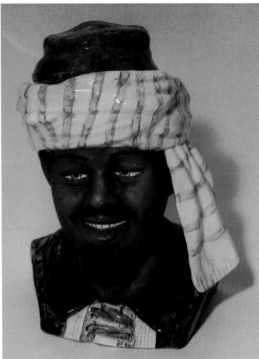

This Indian chief humidor is quite unusual in that the flesh is opaque. Apparently the piece was glazed and fired, the face left untouched. Upon removal from the kiln, a flesh colored stain was applied. The face looks more like that of a woman than a man. The piece is 8½ inches tall. "6627" and "24" are impressed on the bottom on two lines. Estimated value: $450. Photo courtesy of Rod Hollen.

This also has an unglazed face. The numbers "3869" and "55" are impressed on two lines, and the number "78" is painted. The piece is 8½" tall. Estimated value: $350. Photo courtesy of Rod Hollen.

Opposite page:
Etruscan shell and seaweed cup and saucer. The rim of cup is 2¾ inches high when sitting on saucer. The saucer is marked with GSH monogram, the cup unmarked. Griffen, Smith & Company also made coffee cups and saucers in shell and seaweed. Tea cup saucers are 6 inches in diameter. Coffee cup saucers are 7 inches. Eight-inch saucers go with the very rare ($325+) mustache cups. Estimated value of tea cup and saucer: $110. Richard Christen Collection.

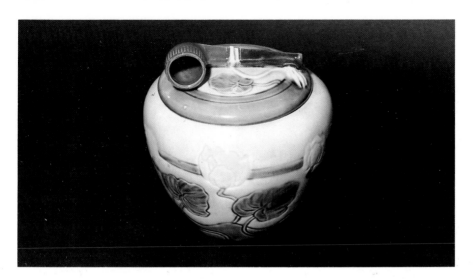

And all humidors aren't figurals, at least not totally. This unmarked piece is 5¼ inches. Estimated value: **$125**. Photo courtesy of Barbara Hall.

CUPS, SAUCERS, MUGS AND TEAPOTS

Majolica cups are generally expensive, simply because they were used so much and were often broken. Saucers are less expensive when they can be found individually; usually a cup and saucer will be sold as a set. Teapots run varying prices depending upon pattern, size, and condition. See pages 22, 23, and 29 for teapot samples.

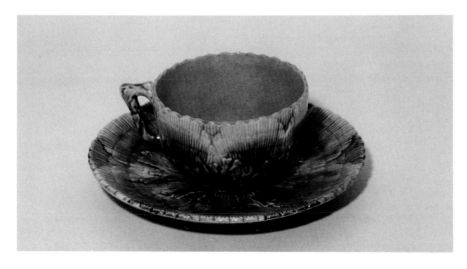

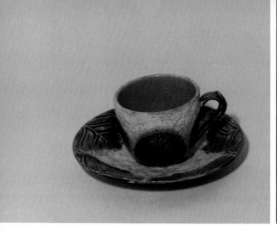
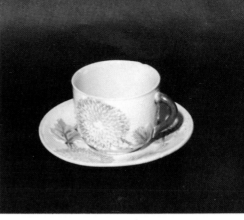

Etruscan cauliflower cup and saucer. The cup is 2¾ inches high when sitting on saucer. Like the shell and seaweed pattern, the saucer is marked with GSH monogram, the cup isn't. Also made in cauliflower were a teapot, creamer, sugar, and plates. Estimated value: $220. Richard Christen Collection.

Flower cup and saucer, 3 inches high when sitting on saucer. Unmarked. Estimated value: $75; without chip: $125. Richard Christen Collection.

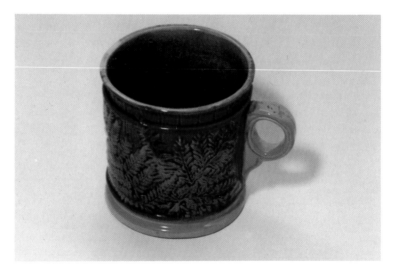

A 3½ inch unmarked fern mug. Estimated value $175. Photo courtesy of Twyla Barron.

Opposite page:

Fern and leaf motif with Greek key around edge. The white flowers are nearly imperceptible. Size is 4" x 9¾". Marked with impressed "S" and the same sunburst as the plate on page 64 (bottom), of which it is similarly colored. Estimated value: $175.

Rare Etruscan footed teapot stand, 7¼ inches diameter. GSH monogram impressed. Estimated value: $325. Richard Christen Collection.

CAKEPLATES

Cakeplates aren't so rare that they are unattainable, but they are not real common either. If you need one it is best to buy it when you have the chance.

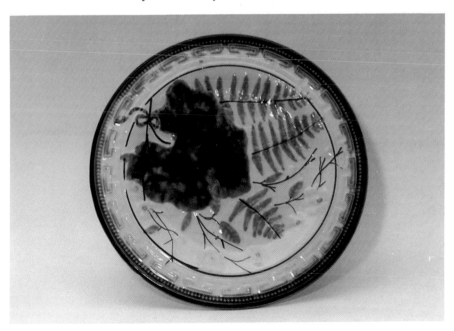

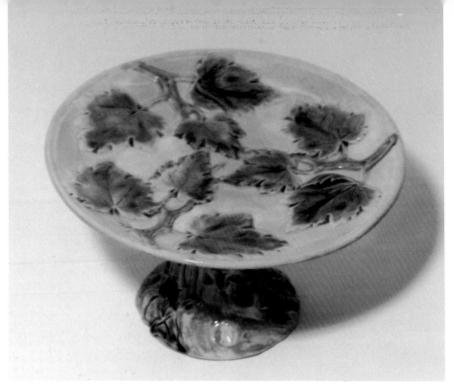

Etruscan maple leaf compote, 5 x 9 inches. Initials "KLW" impressed. Estimated value: $210. Photo courtesy of Judy Fedako.

BOWLS AND COMPOTES

Conch shell bowl on shell feet. Size is 4½" x 9½" x 8½", bowl is unmarked. Estimated value: **$175.**

A figural bowl—for what use is anyone's guess. Size is 5" x 6" x 3½", "10178" is impressed on the bottom. Estimated value: $100. Photo courtesy of Mary L. Rehker.

Opposite page:

Unmarked double grape leaf bowl, 2¼" x 10". Also made in 1½" x 8¼" size. Estimated value: $50; in better condition: **$80;** 1½" x 8¼": **$55.** Photo courtesy of Carter Boylan.

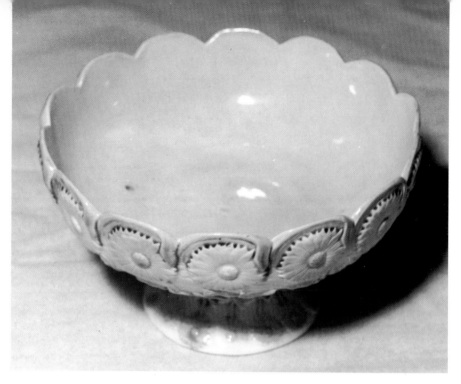

This Etruscan compote has a lovely light pink wash on the inside. Size is 5¼" x 9", GSH monogram impressed. Estimated value: $220. Richard Christen Collection

PLANTERS AND VASES

Vases aren't nearly as common in majolica as in other types of pottery. Given the large number of pitchers that was produced, it's a pretty safe bet that a lot of flowers ended up displayed in them. All of the vases pictured here are comparable in composition to the figural humidors—lighter in weight, generally having a white bottom with numbers impressed.

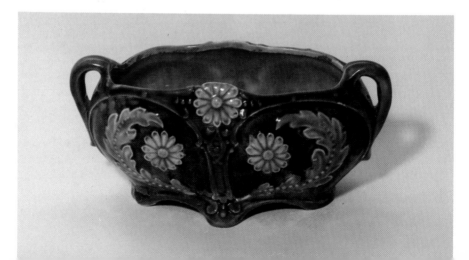

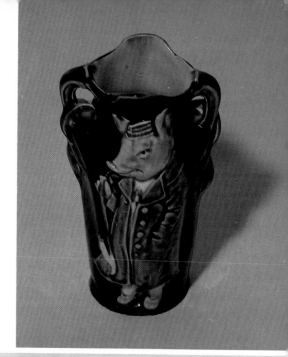

Although he's not on a humidor this pig is still smoking a pipe. No mark, 5½ inches. Estimated value: $110. Photo courtesy of Judy Fedako.

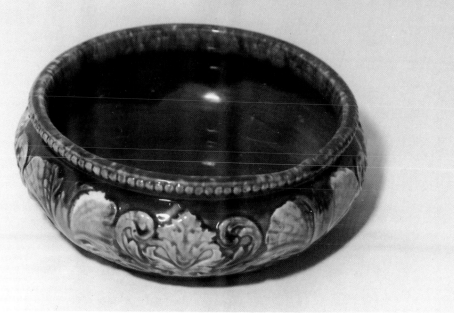

Planter or bowl, take your pick. Unmarked, 3¼ x 8½ inches. Estimated value: **$75**. Photo courtesy of Judy Fedako.

Opposite page:

Size of this planter is 3¼" x 6¼", "10261" impressed. Estimated value: $45. Photo courtesy of Judy Fedako.

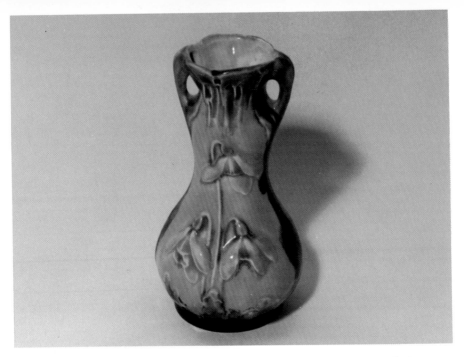

This 6 inch vase has "C394" impressed. Estimated value: $60.
Photo courtesy of Judy Fedako.

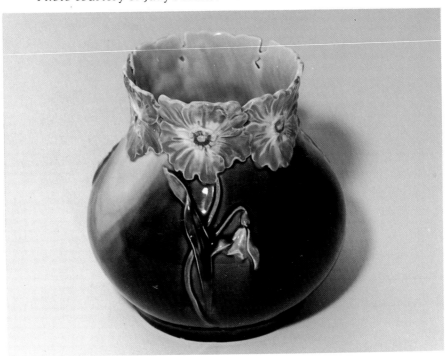

This vase is 6⅞ inches tall. Impressed on the bottom is "4510"
and "60" on two lines. Estimated value: $90.

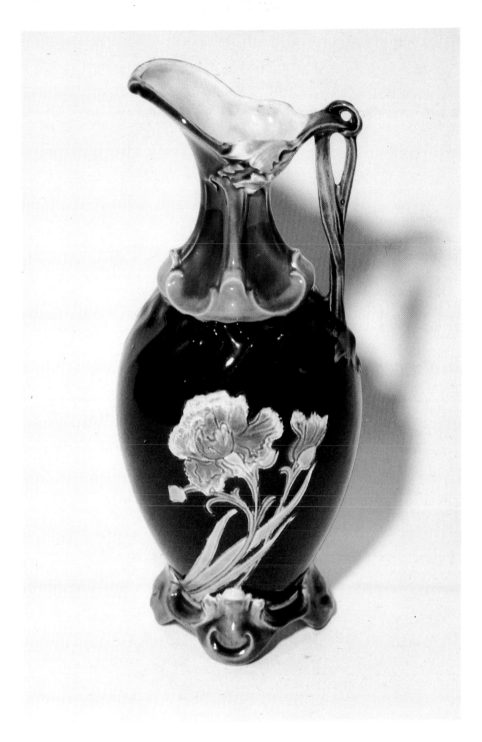

An unmarked 11¼ inch ewer. Estimated value: $110. Photo courtesy of Judy Fedako.

MISCELLANEOUS

Under this catchall category you find everything from oyster servers to calling card holders.

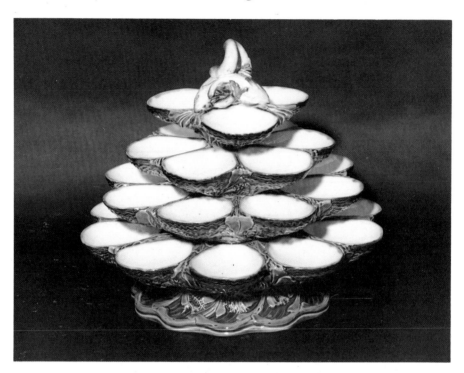

Without a doubt the most outstanding piece of majolica in this book. This "Lazy Susan" of simulated oyster shells is obviously for serving raw oysters. This exquisite piece is 10 x 12 inches and unmarked. Estimated value: $4500. Richard Christen Collection.

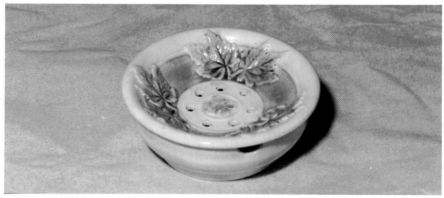

These pieces are called both sponge holders and soap dishes. This one is 2 x 5½ inches, and is unmarked. Estimated value: $140. Richard Christen Collection.

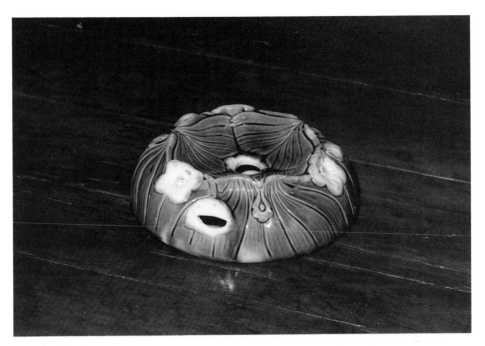

This 3¼ x 8¼ inch piece is unmarked; some attribute it to Holdcroft. Estimated value: $175. Photo courtesy of Frank and Lillian Stigliano.

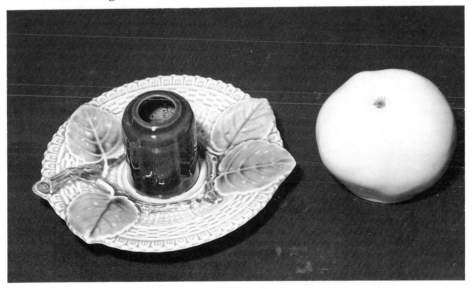

Toothpick holder or inkwell, your choice. Whichever, the apple covers it when not in use. The base has a 6 inch diameter, the apple is 2¾ inches high when sitting on the base. Impressed on bottom is "28." Estimated value: $175. Richard Christen Collection.

Another guessing game. This unidentified piece is unmarked and measures 2¼ x 6¼ inches. Estimated value: $85. Photo courtesy of Leam Williams.

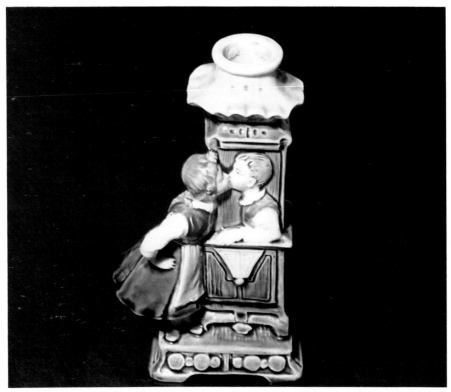

A kissing candlestick, unfortunately only one. This unmarked piece stands 6⅞ inches tall. Estimated value: $135. Photo courtesy of Mary L. Rehker.

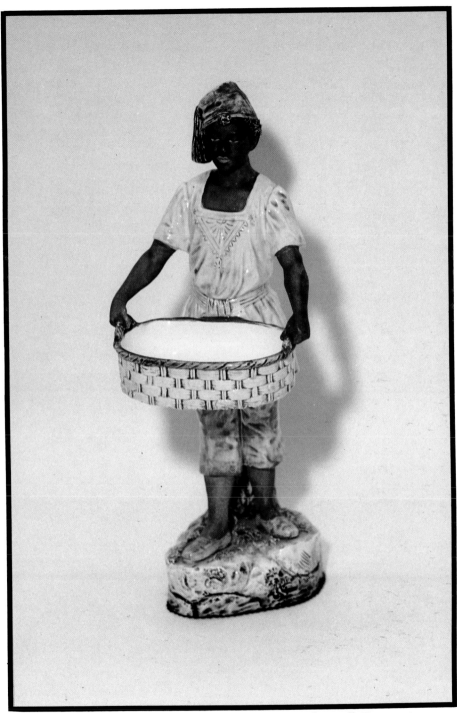

Figural calling card holder. The piece is 15 inches tall. Bottom is covered with felt so it is not known if it is marked. Estimated value: $950. Richard Christen Collection.

Figural calling card holder, 7¼ inches tall. No mark. Estimated value: $350. Richard Christen Collection.

This figural calling card holder is 9½ inches high. It is unmarked. Estimated value: $450. Richard Christen Collection.

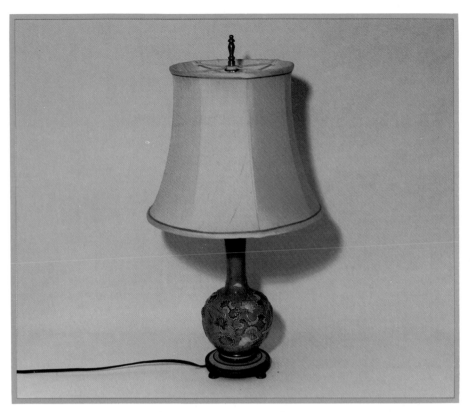

This majolica lamp base is 9¾ inches tall. Compare to ginger jar on bottom of page 77. Unmarked. Estimated value: $125. Richard Christen Collection.

Majolica tiles came in both round and square shapes. They were often made into trivets. This one is 6 inches in diameter. It is unmarked. Estimated value: $65. Photo courtesy of Judy Fedako.

Another colorful trivet, the tile is 5 inches square. This one is also unmarked. Estimated value: $65. Photo courtesy of Judy Fedako.

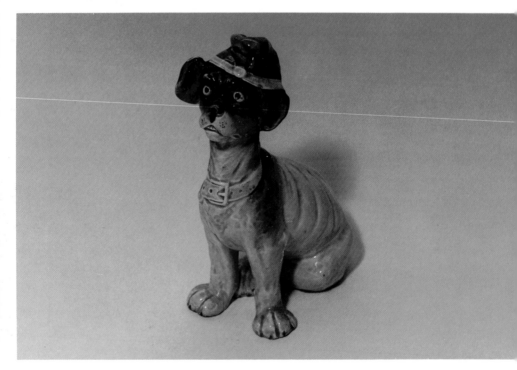

Taking pictures for this book, I attended countless antique shows, visited many shops and viewed several private collections. This is the only figurine I ran into. The dog stands 7 inches tall. "7361" and "74" are impressed on two lines. Estimated value: $200. Dorothy Coates Collection.

SANDED MAJOLICA

Most of the sanded majolica seen today is vases, although other things were also made. Most majolica collectors do not consider it true majolica in the sense of lead-glazed pottery of the Victorian era. Some sanded majolica was made in England.

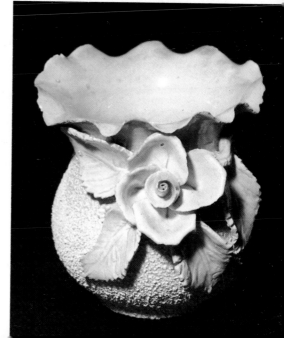

This unmarked vase is 4⅜ x 4 inches. It's condition is typical—broken flower petals, broken leaves. Estimated value: $15; in better condition: $40.

Another typical example of sanded majolica. Note the broken leaf on lower left. The size is 3½ x 3⅝ inches. Estimated value: $10; in better condition: $30.

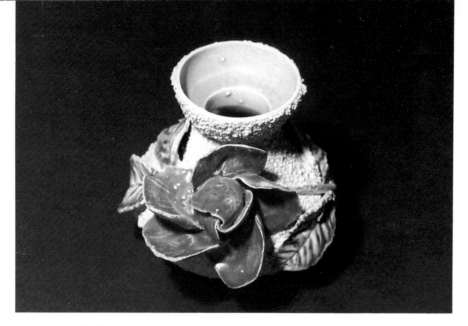

A sanded vase in better condition than the two previous ones. This is 3½ inches tall, "42" inscribed on bottom. Estimated value: $40. Photo courtesy of Mary L. Rehker.

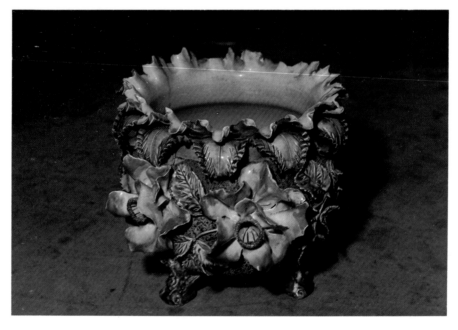

A large jardiniere, 10 x 11 inches. Sanded majolica is thinner and more brittle than normal lead-glazed pottery, and it is hard to find a piece this size without a few dings. "England" is impressed on the bottom. Estimated value: $225. Photo courtesy of Mary Lee, and Jim and Jan Looney.

Chapter 8
Majolica
Those Who Made It

Adams & Bromley

This pottery in Hanley, England is listed in *Keate's Directory* of 1875/6 and is said by some authorities to have only been in business from 1873 to 1886. It was also known as John Adams & Company. Adams & Bromley made majolica both large and small. Included in its majolica line were bread trays, cheese dishes, vases (said to be over four feet tall), garden fountains and garden seats. Marks were impressed. Those known are "ADAMS & Co.," "ADAMS & BROMLEY," and "A & B." It is not known whether all of the company's majolica was marked.

Arsenal Pottery

The Arsenal Pottery was operated in Trenton, New Jersey, by the Mayer Pottery Manufacturing Company which was owned by Joseph S. Mayer. The Arsenal Pottery is said to have made majolica as late as 1893. When it began making it is unknown. It did display lead-glazed pottery at the Centennial where its specialties were Toby jugs and pitchers.

Arsenal didn't mark its majolica.

Banks & Thorley

A pottery in Hanley, England, this company produced majolica, but the dates of manufacture are uncertain. Some sources say lead-glazed pottery was turned out in the mid-1880s. Others say the company was only in business from around 1875 to 1878. It's

listed in *Keate's Directory* of 1875/76 but is not listed in the *Pottery Gazette Diary* of 1900. Banks and Thorley made baskets and covered butter dishes among other items. The company is known for its bamboo and basketweave pattern.

Beck, A.M.

The A.M. Beck Company, of Evansville, Indiana, was started by A.M. Beck, who came from England in 1882 specifically to manufacture majolica. Beck died two years later, and the firm was taken over by Bennighof, Uhl & Company. Bennighof, Uhl discontinued the production of majolica, switching the plant over to whiteware. As far as is known Beck never marked his majolica.

Bennett, Edwin

Like many other producers of American majolica, Edwin Bennett began his career in England, where he is said to have worked for Wedgwood. He came to the United States in 1841 to join a brother, James, who had come over earlier and set up a pottery in East Liverpool, Ohio. James Bennett made yellow ware and Rockingham. By 1846 Edwin had left James's employ and landed in Baltimore to start a pottery of his own. He was 28 years old. Like his brother, he made yellow ware and Rockingham.

Another brother, William, joined Edwin in 1848 and retired eight years later. During William's tenure the firm was known as E & W Bennett.

Exactly when the Bennett's discovered and refined the process for making majolica has been lost to history. However, records of the New York Crystal Palace Exhibition of 1853, which was also known as the Exhibition of the Industry of All Nations, show that the Bennetts displayed a patented blue majolica pitcher that depicted marine life in high relief. Reportedly, the piece was a poor seller.

At the Columbian Exposition in 1893 Edwin Bennett exhibited a majolica bust of George Washington that was dated 1850, the earliest known date on any

American majolica.

When William was with the company the Bennett's used two marks, a simple "E & W," and "E. & W. BENNETT / CANTON AVE. / BALTIMORE MARYLAND," on three lines. Other marks were used later. Most common on majolica was "BENNETT'S" in an arc above a date, for example, "May 12, 1885," and "PATENT" or "COPYRIGHT" in an arc below it.

Paper labels were used on Brubensul ware, a lead-glazed pottery in shades of light and dark brown, which was first marketed in 1894, just one year prior to Edwin Bennett's retirement. It's likely some Brubensul was exported since the label shows a globe and gives the company's address as "Baltimore, MD, U.S.A." Brubensul was most popular for large objects such as pedestals for busts. Brubensul was named by using the first three letters of the names of important people in the pottery—Brunt, Bennett and Sullivan.

Kate DeWitt Berg and Annie Haslam Brinton, Bennett's chief decorator and her assistant, used their own decorator marks, "KB" and "AB." These women were artists, not just painters. It's rather doubtful they decorated anything in the majolica line except samples and proofs.

Bevington, John

A Hanley, England, manufacturer of decorative porcelain in the Dresden style, Bevington operated his pottery from around 1872 to 1892. How much majolica Bevington made, how long he made it and how much was exported is unknown. It is known that he designed and registered a semi-figural pitcher with a swan sitting on top, its long neck and head forming part of the handle, the liquid in the pitcher poured through its tail feathers. The swan design was patented in 1881.

Brown, Westhead, Moore & Company

Operated at Cauldon Place, Hanley, England, probably from about 1862 to 1904. Brown, Westhead,

Moore is listed in both *Keate's Directory* of 1875/76 and the *Pottery Gazette Diary* of 1900. The company is known to have made a basket weave compote setting on a tripod base of bent twigs. The marks used included the full name of the company, "B.W.M. & Co.," and "B.W.M.," all impressed. Brown, Westhead, Moore & Company marks are rarely seen in the United States.

Carr, James

James Carr is a prime example of England's loss becoming America's gain. After working for British potters James Clews and John Ridgway, Carr came to America in 1844, arriving with less than five shillings to his name. He worked for the American Pottery Company of Jersey City, New Jersey, for eight years before going into business for himself. After operating his own small pottery in South Amboy, New Jersey, for one year, he went to New York to crank up the firm of Carr & Morrison. In 1871 the name of the company was changed to the New York City Pottery, which is how it is referred to by most majolica collectors.

Information is sadly lacking on Mr. Morrison, including his first name. Given Carr's potting experience it would seem reasonable to believe that Carr might have handled the creative end of the venture, Morrison perhaps taking care of the business end and supplying the required capital.

Carr made his first majolica sometime between 1858 and 1860. By the Centennial he was specializing in comports, match boxes, pitchers, sardine boxes, and vases, all of which he displayed at the exposition in Philadelphia. In 1878 he displayed majolica at the Paris Exposition, winning high honors.

Cauliflower, and shell-and-seaweed edged with yellow, pink and brown are among his best known patterns.

Carr neglected to mark a lot of his majolica, especially during the early years. That which is marked, carries his monogram, a "J" through the letter "C," which is easily confused with the monogram of George Jones, a "J" through a "G.".

Cartwright Brothers

The Cartwrights started in the pottery business in East Liverpool, Ohio, in 1864, specializing in creamware, Rockingham and yellow ware. The company, known as the Cartwright Brothers, was organized in 1880. Most authorities believe that the Cartwright Brothers turned out majolica about that time. It is probable that none of their majolica was marked. Of the seven known marks used on other types of pottery, three of them say "Cartwright Brothers" amid other details. The other four are unrelated single words—"Avalon" in normal print, "TEXAS" in block letters, and "Brooklyn" and "Elsmere" in cursive letters. Perhaps some majolica slipped through with one of those marks.

A majolica replica of a pressed glass Garfield plate is generally attributed to the Cartwright Brothers.

Chesapeake Pottery Company

The Chesapeake Pottery Company, Baltimore, Maryland, was purchased by David F. Haynes in 1882, just three years after he founded the jobbing firm of D.F. Haynes & Company. Haynes made several different lines of majolica, most of them between 1881 and 1890.

Clifton ware, with a pebbly, cream colored background, was originally made in a blackberry pattern. Later the line was expanded to include strawberries, pineapples, grapes, birds and other natural themes. Clifton is marked by two intertwined crescents surrounding the company's logo. Printed inside the top crescent is the word "CLIFTON," inside the bottom crescent, "DECOR B."

Haynes followed Clifton with Avalon Faience, a more refined pattern which has an ivory background and semi-impressionistic renderings of flowers with gold outlines. Avalon Faience was usually only two colors—the ivory background and the flower color—plus gold, but at times Haynes made sets in five or six colors. Avalon Faience was an early bridge between

the overly indulgent decorating schemes favored by the Victorians, and the simpler lines of the Art Nouveau movement which was just beginning to gather steam. Haynes made lamp bases, vases, complete dinner sets with accessories, and tea sets in Avalon Faience. The line is identified by a mark that can't be missed: the words "AVALON / FAIENCE / BALT," set in a triangle around the company's crest.

The Chesapeake Pottery Company got into financial trouble in 1887, probably the result of very rapid expansion, and was sold at auction to Edwin Bennett. The company then became known as Haynes, Bennett & Co. Bennett, of course, already had his own successful pottery. The two companies always remained separate entities.

Edwin Bennett eventually sold his interest in Haynes, Bennett & Co. to his son, Edwin Houston Bennett. Edwin Houston, in turn, sold his share of the company to Frank R. Haynes who was the son of the original owner, D.F. Haynes. The dates of these transactions are a little murky, but they must have all been completed by sometime in 1896 because during that year the name of the company was changed to D.F. Haynes & Son. The firm continued in business until 1914.

The Chesapeake Pottery Company, under the direction of D.F. Haynes, turned out some of the finest majolica made in America, fully equal to the best that England had to offer.

Copeland, W.T. & Sons, Ltd.

William Taylor Copeland, Stoke-on-Trent, England was in partnership with Thomas Garrett from 1833 to 1847. After the split he called his company by the curious name of "W.T. Copeland, late Spode," because the partnership of Copeland & Garrett had succeeded Josiah Spode.

In 1867 William's four sons were admitted to the company and it became known as W.T. Copeland & Sons, Ltd. William died in 1868 at the age of 71.

The company marked its majolica with an impressed "COPELAND," in block letters, often accompanied by

an English registry mark. Possibly other marks were used, too. It's not known at this time whether or not all of its majolica was marked. Given the rarity with which it is seen, it's evident that very little of Copeland's lead-glazed pottery was exported to the United States.

Among the pieces the company is noted for is an Egyptian-style pitcher with lotus flowers and leaves. The pitchers were made in a minimum of two different heights, 8¼ and 6½ inches.

De Morgan, William

This Merton, England, pottery was established during the early 1870s at the peak of the majolica boom. William de Morgan's majolica has been said to rank among the best. He made basically ornamental pieces such as vases and tiles. Particulary praised by writers in the past has been his ruby-red glaze, which was applied over a cream colored glaze. He also worked a lot in greens and blues.

In 1888 he and Halsey Ricardo, a famous architect of the day, founded the Sands End Pottery in Fulham.

De Morgan's mark was the letters "D M" above a tulip with two leaves. At times the initials of an artist accompanied the mark.

Eureka Pottery Company

Located in Trenton, New Jersey, the Eureka Pottery Company offered at least two lines of majolica. One was an Oriental motif called bird-and-fan, which came in pitchers, tobacco humidors, ice cream sets and dinner service. Eureka's other known pattern depicted a stork standing in a pond among cattails.

Eureka very seldom, if ever, marked its majolica.

Faience Manufacturing Company

The Faience Manufacturing Company specialized in art pottery, but is said to have potted and decorated majolica around 1880, the year it opened for business. Faience Manufacturing Company was located near

Greenpoint, Long Island. Famed English decorator Edward Lycett, who has been called the father of china painting in the United States, joined the firm in 1884. He left in 1890 and the company ceased operations in 1892.

Authorities disagree on the Faience Manufacturing Company's style of majolica. Various accounts state that it made everything from very plain shapes unadorned by any relief, to faience vases with colorful birds and foliage and raised gold trim on a white background. Being that it was an art pottery company during the Victorian era, smart money would have to bet on the second description.

The Faience Manufacturing Company used the letters "FMC" when marking its majolica.

Fielding, S. & Company, Ltd.

Most readers are probably familiar with the trade name "Crown Devon," which this Stoke-on-Trent pottery has used so extensively during this century. The business was founded about 1879, and for some years made excellent majolica. A shell pattern exhibiting a white background was popular, as was a hummingbird pattern, also sporting a white background. In fact, most of the Fielding lead-glazed pottery seen today includes white backgrounds.

The company marked its majolica by impressing "FIELDING" in block letters in a straight line. Sometimes a registry mark was included, too.

Glasgow Pottery

Records of the Centennial Exhibition show that this Trenton, New Jersey company owned by John Moses a one-time associate of James Carr, displayed majolica at Philadelphia in 1876. Most of its wares were said to be utilitarian. Much of its output of ironstone, semi-vitreous wares and white granite can be identified, as the company used more than 25 marks. To this date, however, no majolica has been found with an attributable mark.

The Glasgow Pottery was founded in 1863. The name was changed to John Moses and Sons in 1900 or 1901.

Griffen, Smith & Company.

Of the marked majolica on the American antiques market today there is more Etruscan by Griffen, Smith & Company, than all of the other brands combined.

Following several buy-outs and take overs, this firm evolved from the Phoenixville Pottery, Kaolin and Fire Brick Company, Phoenixville, Pennsylvania, which was founded in 1867.

On Jan. 1, 1879, a partnership of four men—brothers Henry R. and George S. Griffen, David Smith, and William Hill—took over and renamed the firm Griffen, Smith and Hill. William Hill withdrew from the company and his name was dropped before any majolica was produced. The other partners decided to keep Hill's name in the monogram used to mark their products, however, and it's probably for that reason that most collectors today refer to the pottery as Griffen, Smith & Hill instead of Griffen, Smith & Company.

The firm is best known for its fantastic shell and seaweed dinner service which covered all pieces from serving platters down to butter pats, and included such accessories as cider jugs, comports, spooners, cake plates and ice cream dishes.

Another popular design was begonia leaf, which came in a wide array of sizes and colors.

Griffen, Smith & Co. displayed its majolica at the World's Industrial and Cotton Centennial Exposition at New Orleans in 1884, and won gold medals for a pair of vases and a jug. The company prepared a catalog for the exposition which listed 102 different pieces. Wholesale prices ran from a low of one-half cent for butter pats to a high of $1.30 for covered cheese keepers.

As an indicator of how much the wholesalers, retailers and jobbers who attended that trade show

thought of Griffen, Smith's quality, the company received so many orders it had to more than double its labor force in order to fill them.

About that same time the company received a large order from the Great Atlantic and Pacific Tea Company. A & P, which had slightly more than 100 stores in the mid-1880s, gave away Etruscan majolica as a premium in exchange for coupons customers mailed in.

Griffen, Smith & Company used four basic marks. One was the "GSH" monogram. A second was the monogram with the word "ETRUSCAN" underneath. The third is the monogram inside a double circle that has "ETRUSCAN" printed across the top, "MAJOLICA" across the bottom. The rarest mark is "ETRUSCAN" impressed in block letters.

Additionally, many pieces are marked with a letter and number system used internally by Griffen, Smith & Company. For instance, the 8¾ inch sunflower syrup (page 53, top) is designated "E-23," and so marked. Likewise, the shell and seaweed teapot (page 22), is marked "H-16." All these marks, both monograms and letter-number combinations, are impressed.

The little bit of the company's output that wasn't marked can often be spotted by the design, or by the telltale pinkish to lavender hues on the insides of their pitchers and other hollow pieces. On a few pieces light green or pale blue was substituted.

By 1889 David Smith had become a victim of ill health and sold his share of the company to J. Stuart Love, Henry Griffen's father-in-law. Again the name was changed, this time to Griffen, Love & Company.

The following year on Dec. 3, a fire wiped out most of the plant. Four months later the owners had already rebuilt, but they never again made majolica, which might be the first historical indicator that the ware was on its way out, its popularity beginning a downhill slide.

When the plant reopened in April, 1891, the name was changed to the Griffen China Company. The business was dissolved in 1892. Beginning in 1894 three other companies—Chester Pottery, Penn China

Company, and Tuxedo Pottery Company used the plant for varying periods until it was closed permanently in 1903.

Holdcroft, Joseph

Joseph Holdcroft is listed in both *Keate's Directory* of 1875/6 and the *Pottery Gazette Diary* of 1900. The company is said to have operated out of Longton, England, from around 1865 to 1906, or from around 1872 to 1906, depending on which page of the same research book you choose to believe.

Holdcroft's majolica was excellent in every way. Among other things he made plates, footed bowls, trays, pitchers, syrups and serving spoons.

Marks used by the company were "J HOLDCROFT" in block letters, and a "J H" monogram.

Jones, George & Sons Ltd

His majolica being awarded gold medals at the Expositions of Paris (1867), London (1871), and Vienna (1873), this Stoke-upon-Trent, England, potter ran a neck-to-neck race with Minton's for supremacy in the field of lead-glazed pottery in late 19th Century England. That's not surprising; Jones received his training at Minton's.

Some sources say Jones established his pottery in 1861, others say 1865. It lasted until 1951. The "& Sons," was added in 1873.

Jones made oyster plates, sardine boxes, cheese keepers and most other Victorian accessories. Dogwood, one of his most popular majolica patterns, was registered in 1873. Other well-known George Jones patterns are "Iris and Lily," and "Dogwood and Woven Fence."

One of the few potters to combine majolica with another medium, he often made Parian busts to sit on majolica pedestals.

Jones used several different marks on majolica. The simplest is his monogram, a "J" through "G," with a circle around it. Sometimes the J G was given a few

extra loops and appeared without the circle, other times (after 1873) it appeared with a crescent below it that proclaimed "& Sons." Diamond-shaped English registry marks often accompany George Jones's marks.

Lear, Samuel

This Hanley, England, potter is not listed in either *Keate's Directory* of 1875-76 or the *Pottery Gazette Diary* of 1900. It is known he was potting majolica in 1881 because he registered a sunflower design that year. The sunflower design is found on a variety of pieces including cakestands, plates, cups, platters, syrups and pitchers. The sunflower rises from a classical urn, the pattern has a white background.

Minton & Company

No other potter made higher quality majolica than Herbert Minton, the man whose company started it all.

From Stoke-on-Trent, the Englishman Minton was nonetheless very adept at borrowing from the French. Leon Arnoux was brought in from France in 1848 to serve as art director at Minton's, a position he held until 1894. Arnoux is the man who perfected Minton's majolica, which was based upon the work of another Frenchman, Bernard Palissy, a Huguenot who lived in the 1500s.

Shortly after Arnoux had discovered the lead-glaze formula Minton again looked to France, this time for the services of a well-known Limoges artist and sculptor, Paul Comolera. Minton commissioned Comolera to produce a life-size majolica peacock. Comolera completed the molds, made five of the birds and painted each one himself. Standing 54 inches tall, the majolica peacocks are considered to be some of the finest—if not **the** finest—ceramics to ever be made in Great Britain.

Minton pieces likely to be found in this country are asparagus servers, oyster plates, sardine boxes, ink wells, figurine calling card holders, figural dishes and

other Victorian extravagances. All of Minton's work is of an exceptionally high caliber, which probably accounts for so much of it surviving in excellent condition—people who owned it felt its quality deserved better care than ordinary majolica.

Minton's was a large company, employing 1500 workers by 1858, the year Herbert Minton died.

Most of the marks used by Minton's during the majolica-producing period of 1850 to 1900 incorporate the company name. Prior to 1873 the name was "MINTON," after 1873, "MINTONS."

Moore Brothers

A concern in Longton, England, that didn't produce a lot of majolica, but what it did produce is said to be of excellent quality. The pottery operated from 1872 to 1905. It's doubtful any Moore Brothers majolica was exported to America, but some might have been sent as presents or brought back as souvenirs. The company is said to have made a figural teapot in the form of a camel, the animal's neck and head the spout, the handle composed of an Arab strapping on a bale of goods.

The mark the company used is "MOORE," either impressed in block letters or incised in script.

Morley & Company

George Morley learned his skill in his native England, and honed it here in the United States. Arriving in East Liverpool, Ohio, in 1852, he worked for other pottery companies for 18 years, then in a three-way partnership for 8 years, before striking out on his own to establish Morley and Company in Wellsville, Ohio, in 1879. The firm immediately began making majolica and white granite. In 1885 the name was changed to the Pioneer Pottery Company.

Most prized of Morley's majolica are his figural pitchers which include fish, owls and parrots. He also made a napkin plate which simulated a fringed napkin laying on a plate. Syrups were another specialty. On Morley's syrups, incidentally, the pewter lids are

hinged to the handles. Most others are attached to the rims.

George Morley is a good reason to not apply too strict a definition to majolica. His majolica is a much denser, harder-bodied ceramic than the majolica of his contemporaries. Some of his napkin plates aren't majolica at all but white ironstone to which a clear lead glaze has been applied. Here again, however, because they are lead-glazed, because they carry high relief decoration, and because they were made by a company that specialized in majolica, they blend nicely into a collection of majolica.

Morley marked a lot, if not most, of his majolica. His marks are straight forward and easy to understand. The earliest was "MORLEY & CO. / MAJOLICA / WELLSVILLE, O." on three lines. Sometimes majolica was spelled with a two L's instead of one.

Another mark is, "GEORGE MORLEY'S / MAJOLICA / EAST LIVERPOOL, O." also on three lines. This mark is apparently from the pottery he and his son started in East Liverpool, upon his return from Wellsville. Some of the pottery from this plant was also marked "E.L.P. CO."

New Milford Pottery Company (Wannopee)

This Connecticut company got in on the majolica act fairly late, not being formed until June 1887. It turned out its first majolica in 1888. The long held belief has been that the name was changed to Wannopee following financial difficulty and reorganization in 1892. Recent evidence suggests the name had been changed by 1890, fully two years before the concern was bought by E.D. Black, L.F. Curtis, C.M. Beach and Merritt Beach. Sometime between 1892 and 1902 the consortium changed the name to Black and Beach Pottery Company. The firm ceased operations in 1903, was liquidated in 1904.

Its constant financial problems and eventual liquidation can be partially attributed to its late start; it caught majolica after its popularity had peaked and the pottery was beginning a downhill slide. (Even

Griffen, Smith & Co., the largest producer of all, chose not to reenter the field after rebuilding from its 1890 fire.)

New Milford and Wannopee are most famous for producing lettuce leaf majolica, a much thinner and denser majolica than most. It was made to simulate actual lettuce leaves and did a good job. Some was made in pink instead of green. The company is said to have marketed 25 different pieces, most of which sold very well.

Wannopee made large objects in majolica such as umbrella stands and jardinieres, and also smaller things—tea sets, plates, clock cases, candlesticks, etc. Charles Reynolds was the firm's top designer and plant manager. Upon liquidation in 1904, Reynolds bought the molds, copyrights and patents for lettuce leaf, moved to Trenton, New Jersey, and continued to make the popular pattern.

The mark of the original New Milford Pottery Company was the stamped letters, "N.M.P.CO." inside a diamond. Upon reorganization the company chose an impressed sunburst with a "W" inside it. After Reynolds began producing lettuce leaf in New Jersey he used a stamped: TRADE / "LETTUCE LEAF" / MARK on three lines.

Odell & Booth Brothers

Odell & Booth Brothers opened in 1878 in Tarrytown, New York. Records show the company leased a building from 1881 to 1885. How long the company lasted after that is unknown. While in business it must have had its act together as the following excerpt from the January 12, 1882, issue of the *Crockery and Glass Journal* suggests.

"Odell and Booth Brothers, Tarrytown, N.Y., have one of the most complete pottery structures in this country. Their productions are artistic pottery in faience and Limoges decoration, and we saw some very handsome specimens of vases, which for workmanship and beauty of decoration were truly excellent...They are also large producers of majolica ware. Messrs. Odell & Booth Bros. received the silver

medal at the Mechanics' Fair in Boston."

Unfortunately, Odell & Booth Brothers never marked its majolica.

Philadelphia City Pottery

Owned and operated by J.E. Jeffords, who learned the ropes from James Carr in New York. Jeffords displayed majolica at the Centennial including teapots, jardinieres and stands.

J.E. Jeffords and Company founded the Port Richmomd Pottery Company in Philadelphia in 1868. Sometime later the name was apparently changed to Philadelphia City Pottery, or possibly they were always separate entities. Under whatever company name, it's assumed none of Jeffords' majolica was ever marked.

Rubelles S & M

A mark sometimes seen on French majolica, presumably from a pottery near Rubelles, France. All that is known about the company is that it made copies of a Wedgwood lattice-edge plate.

Sarreguemines

See Utzschneider & Company.

Shorter & Boulton

A Stoke-on-Trent pottery said to have operated from 1879 to 1905. Very little is known about this concern other than it registered a bird and fan design in 1881, which it subsequently used on 5 inch majolica sauce dishes and presumably other pieces.

Sneyd, J.

This Burslem, England, potter made a majolica table service around 1867, but probably not too long after as he's not listed in *Keate's Directory* of 1875/76. It's rather doubtful any was exported to America. A small

amount may have come in non-commercially. Sneyd's majolica was marked with an impressed "SNEYD" in capital letters.

Steele, Edward

A native of Hanley, England, Edward Steele manufactured majolica there. In fact, he is said to have specialized in it. It's known that he made teapots, pitchers, vases, and dessert sets with figure centerpieces. An E. Steele, presumably Edward, is listed as a Hanley potter in *Keate's Directory* of 1875/76, but is absent from the *Pottery Gazette Diary* of 1900. The E. Steele firm is believed to have operated from 1875 until just before the turn of the century. Edward Steele never marked his majolica.

Sutherland, Daniel & Sons

A pottery established in Longton, England, in 1863, Daniel Sutherland & Sons probably operated until about 1875. It specialized in majolica and Parian. The firm made many different pieces of majolica including cheese keepers, sardine boxes, covered butter dishes, bread plates, water bottles, pitchers, tea and coffee pots, flower pots, stands, candlesticks and others.

At least some of the company's majolica was marked, the mark being an impressed ""S & S."

Taft, J.S. & Company

James Scollay Taft started into the pottery business like a klutz. He and an uncle attempted to make a pottery out of a former clothes pin factory in Keene, New Hampshire, in 1871. The first time they fired their kiln they burned the factory to the ground. That was in October. By the first of the year they had rebuilt. Six months later they acquired a second pottery through bankruptcy proceedings.

Taft didn't begin making majolica until 1878. At that time his majolica was unmarked. It's said that his earliest pieces were coated with green, brown, yellow and blue glazes. Also, he leaned toward Greek and

Italian styles, and New England asters.

Taft's official trademarks are rare on majolica. "James S. Taft & Co., Keene, N.H." is the one most often seen. Less common is, "J.S.T. & Co., Keene, N.H." A third is "Hampshire Pottery." One of Taft's better painters, Eliza Adams, sometimes signed her initials, "E.A."

Taft sold the factory and retired in 1914.

Tenuous Majolica

Here is the reverse of the problem most often faced when trying to identify majolica. Tenuous marked its wares. But where was the factory, who owned it, and when did it operate? Was the company American or foreign? None of the questions have ever been answered to satisfaction.

Tenuous Majolica is known to have made leaf-shaped butter pats and trays of the same design, and a cuspidor with a seashell motif.

The mark is the word "TENUOUS" impressed in an arc above the word "MAJOLICA," in an arc below it.

Trent Pottery

Contemporary of Minton that made majolica including "large and ornate show pieces made for London & Paris Expositions." Marks are not known.

Utzschneider & Company

A French factory established at Sarreguemines, Lorraine, in 1770. It specialized in French faience and was once considered one of the top faience potteries in France. Its lead-glazed pottery from the Victorian era is usually stamped "SARREGUEMINES," in capital letters.

Wannopee Pottery Company

See New Milford Pottery Company.

Wardle & Company

A Hanley, England, concern operating from 1871 to 1909, Wardle & Company was a credit to British potters. Wardle made footed bowls, regular bowls, tea sets, trays, pitchers and other pieces. Its designs, all of which were registered, include birds, sunflowers, bamboo, and ferns.

Wedgwood

According to his experiment books, Josiah Wedgwood discovered majolica on March 23, 1759, 92 years before Herbert Minton unveiled Leon Arnoux's version at London's Great Exhibition. What Wedgwood concocted that day was a clear green glaze that could be laid over earthen wares, including those molded in relief. At the time Wedgwood was in partnership with Thomas Whieldon. Both Wedgwood and Whieldon went on to make lead-glazed pottery with relief decoration that today is commonly called Whieldon ware.

Following the Crystal Palace Exhibition, the Wedgwood Company waited nine years to jump onto the majolica bandwagon, offering its first pieces in 1860. Wedgwood made dessert sets, dinner services including shell and seaweed, vases, jardinieres, umbrella stands—most of the things made by other companies.

Like that of most British potteries, Wedgwood majolica shows a higher degree of sophistication than that from the majority of American potteries. The molds were made with greater attention paid to detail, the ware was cleaned better and painted more accurately.

Most of Wedgwood's majolica is marked with an impressed "WEDGWOOD."

Wedgwood ceased majolica production in 1910.

Whieldon, Thomas

Thomas Whieldon operated a pottery in England from 1740 to 1780. Though he died long before the

Great Exhibition of 1851, no discussion of lead-glazed pottery would be complete without him. Improving on Wedgwood's 1759 discovery of a clear green glaze, Whieldon went on to create other colors and produce wonderful accessories in cauliflower, pineapple and cabbage motifs. Whieldon never marked his wares so attribution is impossible. Today lead-glazed ceramics of the style he executed are called "Whieldon ware" regardless of who made them. Several authorities call Whieldon's work the finest lead-glazed pottery in existence. Whieldon ware usually has a white body. It's generally seen in museums, not at antique shows and shops.

Willets Manufacturing Company

Most people are familiar with this Trenton, New Jersey, company's American Belleek, few know that it also made majolica. Exactly when or how much is not known, but majolica doorknobs, of all things, are said to have been on its list.

Woodward, James

An Englishman who made majolica at Swadlincote, Derbyshire, beginning about 1860. It's said he turned out a large amount of lead-glazed pottery, so possibly some of it was exported. His mark was "a foul anchor, the cable twisted around the stem to form the monogram, J W."

Worcester Royal Porcelain Company, Ltd.

Originally established in 1751 in Bristol, England, by Dr. John Wall and a group of investors, the Worcester Royal Porcelain Company, Ltd. made majolica during the last half of the 19th Century, certainly after 1862, possibly before.

The company liked dolphins, making a dolphin compote well in advance of Griffen, Smith & Company, and also dolphin candlesticks. Worcester's majolica is not often seen in the United States.

The company's mark on majolica was an impressed crown over a circle, the circle filled with four W's written in a calligraphic style.

Bibliography

Berrill, M. Jacquelyn. "The Past in My Hands," *Hobbies*, January, 1948.

Bjerkoe, Ethel Hall. "Majolica or Tin-Plated Pottery," *Hobbies*, November, 1957.

Converse, P.D. *Dictionary of American History*, Charles Scribner's Sons, New York, 1940.

Cooper, Emmanuel. *A History of World Pottery*, Larousse, New York, 1981.

Cushion, John P. *Animals in Pottery and Porcelain*, Crown, New York, 1974.

Diamond, Herbert Maynard. *Dictionary of American History*, Charles Scribner's Sons, New York, 1940.

English and American Ceramics of the 18th and 19th Centuries—A Selection from the Collection of Mr. and Mrs. Harold G. Duckworth, The Toledo Museum of Art, Toledo, Ohio, Staff-written, 1968.

Evans, Paul. *Art Pottery of the United States*, Charles Scribner's Sons, New York, 1974.

Freeman, Larry. *China Classics 1. Majolica*, Century House, Watkins Glen, New York, 1949.

Freeman, Larry. "Majolica Pitchers," *Hobbies*, July 1946.

Godden, Geoffrey A. *The Handbook of British Pottery & Porcelain Marks*, Frederick M. Praeger, Inc., New York, 1963.

Godden F.R.S.A., Geoffrey A. *British Pottery and Porcelain 1780-1850*, A.S. Barnes, New York, 1963.

Hobbies, "Pointers for the Majolica Collector," staff written, July, 1954.

Honey, W.B. *Wedgwood Ware*, Faber and Faber, London, England, 1956.

Hughes, G. Bernard. *Victorian Pottery & Porcelain*, MacMillian, New York, 1959.

Jackkson, Mary L. *If Dishes Could Talk*, Wallace-Homestead, Des Moines, Iowa, 1971.

Jones, Simon. "Maiolica—Ceramic Art of the Renaissance," *Antiques & Collecting Hobbies*, August, 1988.

Kovel, Ralph M. and Terry H. *Dictionary of Marks--Pottery and Porcelain*, Crown, New York, 1973.

LaGrange, Marie J. and Goldman, J.D. "More About Makers of American Majolica," *Hobbies*, June, 1939.

Lamp, Ann Louise. "Majolica," *The Antique Reporter*, December-January, 1973-74.

Lehner, Lois. *Encyclopedia of U.S. Marks on Pottery & Porcelain*, Collector Books, Paducah, Kentucky, 1988.

Liverani, Giuseppe. *Five Centuries of Italian Majolica*, McGraw-Hill, New York, 1960.

Marks, Mariann K. *Majolica Pottery—An Identification and Value Guide*, Collector Books, Paducah, Kentucky, 1989.

Marks, Mariann Katz. *Majolica Pottery—An Identification and Value Guide*, Second Series, Collector Books, Paducah, Kentucky, 1989.

Monaghan, Frank. *Dictionary of American History*, Charles Scribner's Sons, New York, 1940.

Ramsay, John. "American Majolica," *Hobbies*, May 1945.

Rebert, M. Charles. *American Majolica 1850-1900*, Wallace-Homestead, Des Moines, Iowa, 1981.

Reilly, Robin. *The Collector's Wedgwood*, Portfolio Press, Huntington, New York, 1980.

Rickerson, Wildey C. *Majolica—It's Fun to Collect*, Wildey C. Rickerson, Deep River, Connecticut, 1963.

Rolfe, Richard Carman. "The Enigma of Majolica," *Hobbies*, May, 1949, reprinted from *Magazine Old Glass*.

Robacker, Earl F. *Old Stuff in Up-Country Pennsylvania*, A.S. Barnes, Cranbury, New Jersey, 1973.

Schneider, Mike. "Colorful, Vivid and Shiny American Majolica Screams Out," *The Mountain States Collector*, February 1987.

Schneider, Mike. "Magnificent Majolica," *The Antique Trader Weekly*, October 26, 1988.

Schneider, Mike. "Majolica Seldom in Perfect Condition," *Antique Week*, May 19, 1986.

Schwartz, Marvin D. *Collector's Guide to Antique American Ceramics*, Doubleday, Garden City, New York, 1969.

Stanley, Louis T. *Collecting Staffordshire Pottery*, Doubleday, Garden City, New York, 1963.

Stern, Anna. "Majolica—Flamboyant Victorian Ware," *Time-Life Encyclopedia of Collectibles*, Time-Life Books, Alexandria, Virginia, 1977.

Tiry, Bud. "Glaze Distinguishes Majolica," *Collector's Weekly*, January 15, 1974.

Wedgwood, Josiah and Ormsbee, Thomas Hamilton. *Staffordshire Pottery*, Robert M. McBride, New York, 1947.

Weidner, Brooke. *Catalogue of Majolica 1884*, Reprint, Brooke Weidner, Phoenixville, Pennsylvania, 1960.

Williams, Lena. "Majolica, Like Gold Is Where You Find It," *Hobbies*, January, 1952.

Zeder, Audrey B. "Majolica—The Wonderful World of Fantasy Pottery," *Antiques & Collecting Hobbies*, June, 1985.